DOWN
by the Sea

WITH BRUSH & PEN

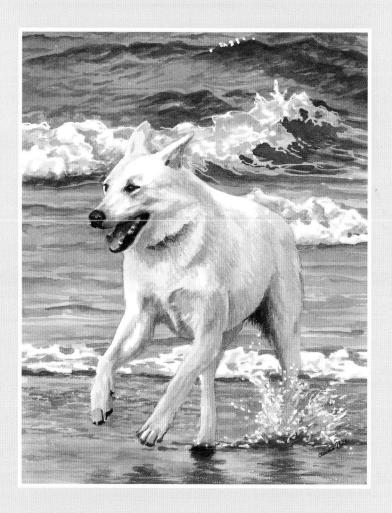

Draw and paint beautiful coastal scenes

"CAPE LOOKOUT, INCOMING TIDE" Watercolor and gouache, 14 x 18 inches (36 x 46cm)

DOWN
by the Sea

WITH BRUSH & PEN

*Draw and paint beautiful
coastal scenes*

CLAUDIA NICE

NORTH LIGHT BOOKS
Cincinnati, OH
www.artistsnetwork.com

Other fine North Light Books are available from your
local bookstore, art supply store, online supplier or visit
our website at www.fwmedia.com.

13 12 11 10 09 5 4 3 2 1

Distributed in Canada by Fraser Direct
100 Armstrong Avenue
Georgetown, ON, Canada L7G 5S4
Tel: (905) 877-4411

Distributed in the U.K. and Europe by David & Charles
Brunel House, Newton Abbot, Devon, TQ12 4PU, England
Tel: (+44) 1626 323200, Fax: (+44) 1626 323319
Email: postmaster@davidandcharles.co.uk

Distributed in Australia by Capricorn Link
P.O. Box 704, S. Windsor NSW, 2756 Australia
Tel: (02) 4577-3555

Library of Congress Cataloging-in-Publication Data
Nice, Claudia
 Down by the sea with brush & pen / Claudia Nice. -- 1st ed.
 p. cm
 Includes index.
 ISBN: 978-1-60061-163-6 (hardcover : alk. paper)
 1. Sea in art. 2. Painting--Technique. 3. Pen drawing--
Technique. I. Title.
 N8240.N53 2009
 751.42'2437--dc22
 2009006865

Edited by Kathy Kipp
Design and layout by Clare Finney
Production coordinated by Matthew Wagner

ABOUT THE AUTHOR

Claudia Nice is a native of the Pacific Northwest and a self-
taught artist who developed her realistic art style by sketching
from nature. She is a multi-media artist, but prefers pen, ink,
and watercolor when working in the field. Claudia has been
an art consultant and instructor for Koh-I-Noor/Rapidograph
and Grumbacher. She is also a certified teacher in the Winsor &
Newton Col Art organization and represents the United States as
a member of the Advisory Panel for The Society Of All Artists in
Great Britain.

Claudia travels internationally conducting workshops,
seminars and demonstrations at schools, clubs, shops and trade
shows. She has opened her own teaching studio, Brightwood
Studio (www.brightwoodstudio.com) in the beautiful Cascade
wilderness near Mt. Hood, Oregon. Her oils, watercolors, and ink
drawings can be found in private collections across the continent
and internationally.

Claudia has authored more than twenty successful art
instruction books. Her books for North Light include *Sketching
Your Favorite Subjects in Pen & Ink; Creating Textures in Pen & Ink
with Watercolor; How to Keep a Sketchbook Journal;* and her latest
book, *Creating Textured Landscapes with Pen, Ink and Watercolor,*
published in 2007.

When not involved with her art career, Claudia enjoys gar-
dening, hiking, and horseback riding in the wilderness behind her
home on Mt. Hood.

METRIC CONVERSION CHART

To convert	to	multiply by
Inches	Centimeters	2.54
Centimeters	Inches	0.4
Feet	Centimeters	30.5
Centimeters	Feet	0.03
Yards	Meters	0.9
Meters	Yards	1.1

I dedicate this book to all who love the sea, the tang of the salt air, and long strolls on the beach; and especially to my husband Jim, with whom I've shared many ocean sunsets.

I acknowledge the creator of heaven, earth and sea, my inspiration.

Claudia Nice

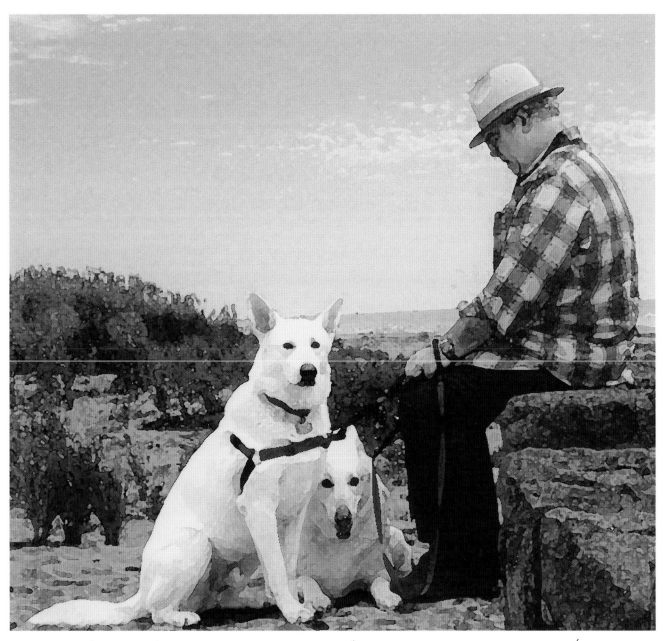

A digital painting of my husband, Jim and our two beach loving white shepherds, Merlin and Dakota Snow.

Contents

High Tide

The restless waves stretch and flow
Above the high tide's mark.
The sun-parched sand drinks deeply,
Spreads out smoothly, and turns dark.

Like childish gifts of friendship,
Offered to the beach,
The sea lines up its flotsam,
At its most extended reach.

Bottles, floats and fish bones,
Shells and foreign goods,
Lay among the sea weed
And bits of wormy wood.

— Nice

A Treasure Chest of Tools & Techniques

THE BEST PART OF PAINTING WITH WATER-COLOR is that you can start with just a few brushes, six tubes of paint, and paper. A white dinner plate can be used as a palette; a glass or cottage cheese tub makes a good water container; and a no. 2 pencil works just fine to sketch out your preliminary scene. Oh, yes, you will also need some masking tape to tape the edges of your paper to a flat, waterproof surface to keep it from buckling.

BRUSHES

Watercolor brushes should be able to hold a great deal of water, so that the artist can make long flowing lines or large wash areas without continually stopping to refill his brush. Sable hair brushes hold the best reservoir of water and have a good, springy feel. They are also the most expensive, with Kolinsky sable being the top of the line. Quality sable/synthetic blend brushes will do if one is starting out on a budget.

Watercolor brushes come in two basic shapes, round and flat, with a few slight variations as shown on the opposite page. Size will depend on how large you wish to work. If your paintings are going to be 9x12 inches (23x30cm) or smaller, choose a no. 4 round detail brush, a no. 8 round brush and a ½-inch (13mm) aquarelle or flat brush. A flat, stiff

synthetic scrubber is also useful and inexpensive. This basic brush collection will get you started.

In choosing your brushes, look for a neat, attractive brush head with no bent or loose hairs. The ferrule should be firmly attached to the handle. Round detail brushes should come to a sharp point and the hairs of a flat brush should flow together forming a straight, chiseled edge. A brush must be dipped in water to remove the sizing so that it can be judged accurately. Most dealers will allow this.

PAINT

Watercolor is made up of pigment, a binder (usually gum arabic), glycerins and sugars for moistness, a wetting agent for disbursement, a preservative and water. Paint companies may add special ingredients to make their brands unique. For instance, M. Graham watercolors (used in this book) contain honey for extra moistness.

It's hard to tell what the paint will be like when it's in the tube, so ask around and consider the advice of your peers. Whatever the brand you choose, it's better to buy a few tubes of artist quality paint rather than lower priced student grade. The colors will be richer, with a smooth, even consistency that will spread further.

You will need a warm and cool red, yellow and blue to get started. See the color wheel on page 13.

Gouache is basically a watercolor paint that has a higher concentration of larger particles of pigment, making it opaque. It's fun to use in conjunction with standard watercolor paints to add final touches of bright color or white highlights. I would recommend at least having a tube of Titanium White gouache.

Watercolor Brushes

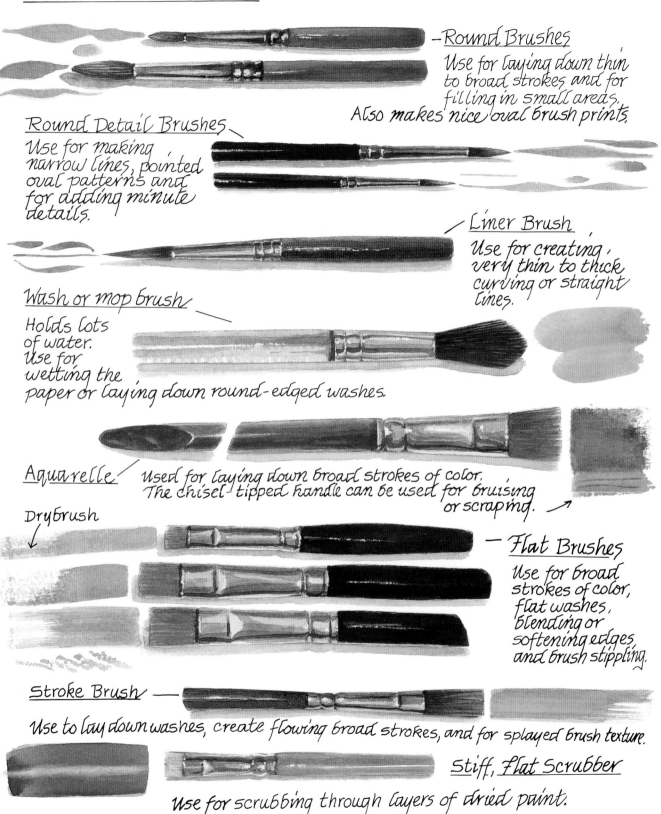

Round Brushes
Use for laying down thin to broad strokes and for filling in small areas. Also makes nice oval brush prints.

Round Detail Brushes
Use for making narrow lines, pointed oval patterns and for adding minute details.

Liner Brush
Use for creating very thin to thick curving or straight lines.

Wash or mop brush
Holds lots of water. Use for wetting the paper or laying down round-edged washes.

Aquarelle
Used for laying down broad strokes of color. The chisel-tipped handle can be used for bruising or scraping.

Drybrush

Flat Brushes
Use for broad strokes of color, flat washes, blending or softening edges, and brush stippling.

Stroke Brush
Use to lay down washes, create flowing broad strokes, and for splayed brush texture.

Stiff, Flat Scrubber
Use for scrubbing through layers of dried paint.

PAPER

I use a 140-pound, cold press watercolor paper for most of my paintings. Paper quality is very important and has a great deal to do with how well the paint flows over the surface and how frustrated the artist becomes. Student grade watercolor papers often have coarse, stamped textures and heavy amounts of sizing which tend to repel the watercolor paints. I recommend the artist quality watercolor papers manufactured by Winsor & Newton, Arches and Savoir Faire.

OTHER SUPPLIES

Other useful painting tools include paper towels, facial tissues for texturing, non-permanent masking fluid or a bottle of Masquepen, a razor blade, a kitchen sponge, a sea sponge, and a waterproof backing board.

PAINTING WITH ACRYLICS

There are three main differences in the tools you will need for working in acrylics rather than watercolors. First you will need acrylic based paints. Add a tube of Titanium White to your six basic primary colors. Acrylic paints are opaque, which allows you to paint in your white areas rather than using the white of the paper, as you would in a watercolor painting. Acrylic paints dry fast and permanent. Although not an absolute necessity, acrylic extender will increase the length of time your paint will stay workable on the palette.

Your brushes need to be a bit stiffer to handle the thicker acrylic paint. Synthetic or synthetic blend brushes will work fine. They should be cleaned promptly after each use with artist's soap and water to keep them in good condition. I do not recommend using your good watercolor brushes with your acrylic paints. It will shorten their lifespan.

Last of all, you will need to work on a canvas paper or a stretched canvas rather than watercolor paper. You may also want to invest in a disposable acrylic paper palette for convenient clean-up, although dried paint will scrape off of a shiny plate.

PEN AND INK

Artists now have a vast array of pens and inks to choose from. With so many variations available, here are the characteristics to look for. The pen should produce a consistent line which flows freely. The ink should not only be waterproof but brushproof. In other words, when the ink is dry, one should be able to brush yellow watercolor over it and the color remain bright yellow. I recommend Rapidograph technical pens filled with 3080 Universal Black India Ink, Pigma Micron Pens and Faber-Castell Pitt artist pens. Fine nibbed dip pens can also be used, but you will be limited in the direction you can stroke. For a colored ink, I prefer FW Acrylic Artists Ink.

Basic Pen Strokes

 (Contour) (Parallel)

Contour Lines

Lines that flow over the curves and planes of a subject, but do not cross over each other.

- Smooth, solid subjects
- Water in motion

Parallel Lines

Hand-drawn straight lines which run horizontal, vertical or diagonal.

- Flat, smooth subjects
- distant objects
- To depict objects in a fog

Crosshatching

Two or more sets of contour or parallel lines which are stroked in different directions and intersect.

- Rougher textured objects
- fabric, netting
- Produce shadow areas
- Shingles
- Barnacle-covered rocks

Dots or Stippling

Dots are produced by touching the pen nib straight down upon the paper.

- Dusty, gritty or sandy texture
- Creates an aged appearance
- Makes good clouds or water spray.

Wavy Lines

Lines which are drawn side by side and form a rippling pattern.

- Wood grain
- Water ripples
- feather barbs

Scribble Lines

A continuous line which twists about in a free-flowing, whimsical manner.

- Foliage
- Clouds
- Sea foam, spray
- fluffy textured objects.

Crisscross Lines

Lines which are laid down at slightly varied angles and are allowed to cross randomly.

- Grass
- Hair, fur

Setting Up Your Palette

It is hard to find an absolutely pure primary red, yellow and blue from which to mix vivid secondary and tertiary hues. For instance, if a paint tube labeled red contains a bit of yellow in its mix, it will produce bright oranges, but dull, muted violets. The solution is to use six primary mixing colors, a warm and cool representative for each primary hue. The color wheel (opposite page), shows how and when to use these basic mixing colors effectively. Choose your primaries from the six lists shown below. My favorite choices are underlined.

Warm Yellow
(leans toward orange)

Cadmium Yellow
Cadmium Yellow Deep
New Gamboge
Hansa Yellow Deep

Warm Red
(leans toward orange)

Cadmium Red Light
Scarlet Lake
Cadmium Scarlet
Scarlet Pyrrol

Warm Blue
(leans toward violet)

French Ultramarine
Ultramarine Blue

Cool Yellow
(leans toward green)

Azo Yellow
Aureolin Yellow
Winsor Lemon
Cadmium Yellow, Lt
Hanza Yellow
Bismuth Yellow

Cool Red
(leans toward violet)

Quinacridone Rose
Permanent Rose
Permanent Alizarin Crimson
Permanent Carmine

Cool Blue
(leans toward green)

Phthalocyanine Blue
Thalo Blue
Winsor Blue (green shade)
Turquoise
Manganese Blue Hue

The secondary colors are used frequently in mixing. Therefore it is convenient to have a quantity of orange, green and violet available on the palette. It can either be mixed up from the primaries or purchased in the tube.

Green
Permanent Green
Winsor Green (Yellow shade)

Orange
Cadmium Orange
Azo Orange

Violet
Dioxazine Purple
Winsor Violet

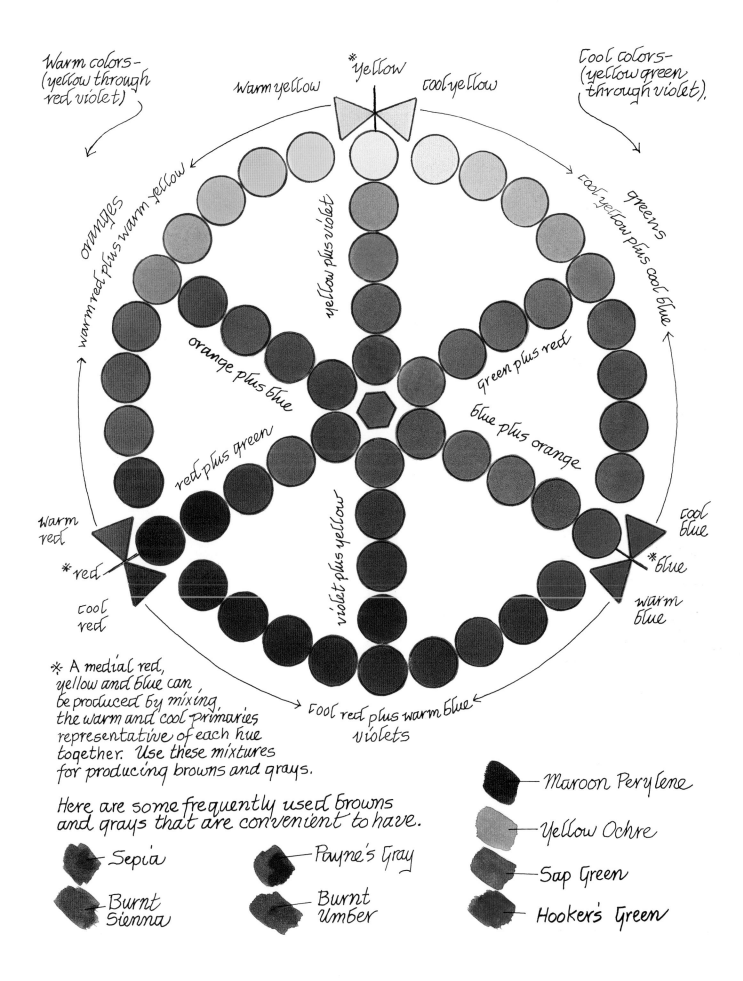

Warm colors-
(yellow through
red violet)

Cool colors-
(yellow green
through violet).

* Yellow

Warm yellow

Cool yellow

oranges

warm red plus warm yellow

yellow plus violet

greens

cool yellow plus cool blue

orange plus blue

green plus red

blue plus orange

red plus green

Warm red

* red

Cool red

violet plus yellow

cool blue

* blue

warm blue

Cool red plus warm blue
violets

※ A medial red,
yellow and blue can
be produced by mixing
the warm and cool primaries
representative of each hue
together. Use these mixtures
for producing browns and grays.

Here are some frequently used browns
and grays that are convenient to have.

Sepia

Burnt
Sienna

Payne's Gray

Burnt
Umber

Maroon Perylene

Yellow Ochre

Sap Green

Hooker's Green

Applying Washes

Washes are thin mixtures of water and pigment that are brushed quickly and evenly across the surface of the paper to form smooth, colored areas of uniform tone. Small wash areas can be applied to a dry or damp surface with a round brush.

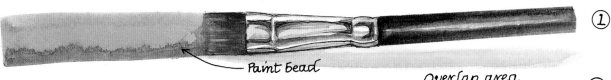

Paint Bead

①

Large, flat wash areas are applied to a damp, well blotted surface, using a flat brush.

1. Mix up an ample paint puddle on the palette. Fill the brush and stroke it across the top of the designated wash area keeping the work surface tilted enough to cause excess fluid to flow downward to the bottom of the paint stroke. This gathering of fluid is called the bead.

overlap area

②

2. The second stroke should overlap the previous paint mark so that the bead is picked up and carried along. A new bead of fluid should form along the bottom edge of the second stroke. If not, the brush is not being kept wet enough.

3. Proceed using overlapping strokes until the wash area is filled in. Work quickly, with as few strokes as needed to get the job done. Wick up the last row of excess bead fluid with a damp brush.

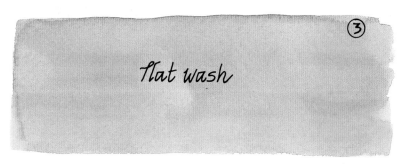

③

Flat Wash

One-color flat washes can be changed into graded value washes by stroking in water instead of a water/paint mix. Color changes may be produced in a similar manner.

Graded Wash

Color change wash

Masking and Drybrush

sea foam

Masking is a dry surface technique in which a shield is put on selected portions of the watercolor paper or over dry painted areas to protect them while a layer of paint is applied.

Water spray

Masking tape can be used to shield a long, wide shape such as a dock piling.

Masking fluid, applied with a brush (coated with soap suds), an Incredible (felt) nib, or Masquepen application bottle, makes delicate foam or sea spray areas.

Hints for easy masking —

1. Don't leave the masking fluid in place for more than a day or two.

2. Make sure the area is dry before removing.

Drybrush technique works well to create the look of old wood. →

Round brush

3. Use masking tape rolled sticky side out around your index finger and rub the mask away. Don't rub it with your bare finger as finger oil may cause smearing.

Flat brush

Drybrushing is a dry surface technique which utilizes a blotted brush and the texture of the watercolor paper to produce a rough pattern of partial paint coverage. The brush deposits paint on the raised portions of the paper and the valleys are left the original color.

Although a flat brush is usually used, round brushes also create interesting patterns. Simply fill the brush with paint, blot it well on a paper towel and brush it lightly over the surface.

15

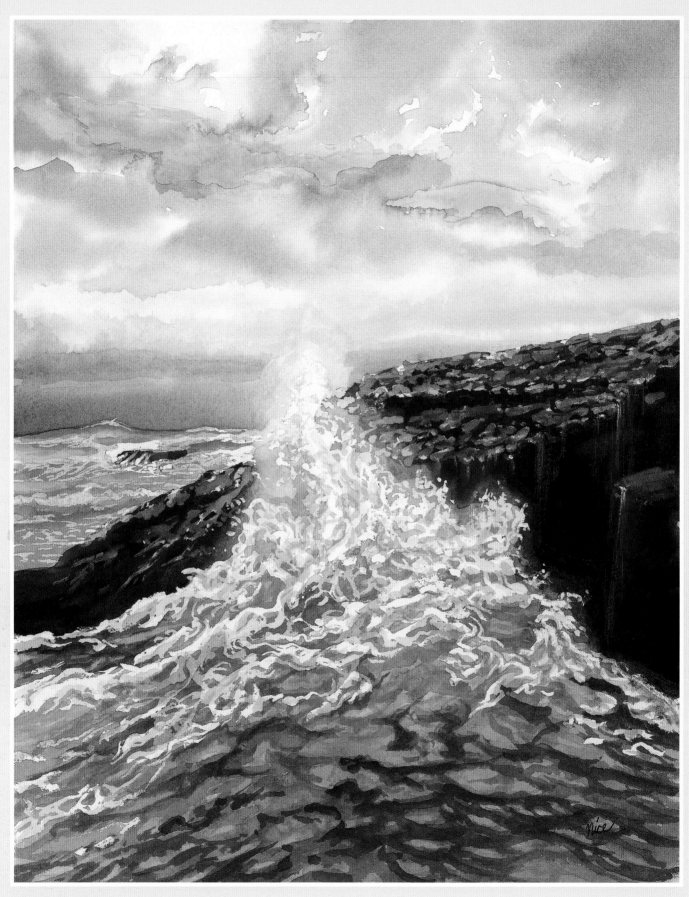

"SURGING SEA" Watercolor and gouache, 8 x 10 inches (20 x 25cm)

1

Painting the Seething Surf

AS THE OCEAN ROLLS INTO THE SHALLOWS, sending massive swells ashore, it creates an unending source of subject matter. In this explosive scene, the water roars and curls and kicks back into far-flung spray, while thick patches of foam hold fast to the bucking surf like a gathering of bull riders clinging to their raging mounts. It's the rare artist who can view the antics of the surf and not long to explore it with pencil, brush or pen. It doesn't matter what medium you choose, the spirit of the sea can be expressed quite well with all of them.

Watercolor is my choice when I wish to portray sunlit surf, with a myriad of highlights dancing on its surface, and breakers that are so transparent at their crest that you can almost see through them. Nothing beats watercolor and the white of the paper for lending brightness to a scene.

Gouache, being opaque, is a more forgiving type of watercolor. It has a heavier look and lends itself well to stormy, brooding seascapes. I find it most useful in adding final specks of highlight and bright color to my watercolor scenes.

Acrylic paint and crashing waves are a great creative combination. The artist can layer streamers of froth over the dark, turbulent water according to her creative whims. Spray can be ardently stroked, dotted or flicked into place as the mood strikes. Although acrylic seascapes lack the airy transparency of watercolor, they are great for capturing the power and energy of the surf.

Pen and ink lends itself well to relating the movement of the waves and the textures of sand, rock and water spray. The most dramatic light-against-dark contrasts can be achieved with pen and India ink. Penwork and watercolors make a nice combination.

In this chapter I will show you how to mix the colors of the cold-water oceans and seas. Then I'll show you how to use those colors to paint realistic waves in watercolor, using masking and glazing techniques.

The painting on the facing page, "Surging Sea," is an example of a watercolor seascape with finishing touches of gouache. You'll find step-by-step instructions for this painting and many others, including acrylic seascapes, within the pages of this chapter. Open your imagination. Smell the salty air, feel the sea-spray against your cheek and hear the roar of the pounding surf. Are you ready to capture the scene? Turn the page.

Ocean Hues

The oceans in colder, non-tropical regions of the world are usually muted shades of blue-green, blue gray and blue. Below are some mixtures that work well.

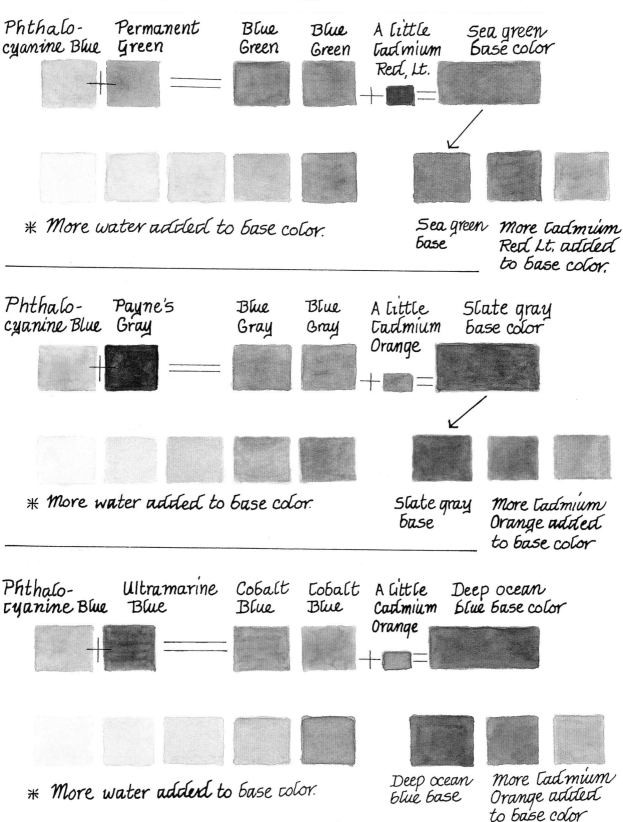

Phthalocyanine Blue + Permanent Green = Blue Green

Blue Green + A little Cadmium Red, Lt. = Sea green base color

Sea green base — More Cadmium Red Lt. added to base color.

* More water added to base color.

Phthalocyanine Blue + Payne's Gray = Blue Gray

Blue Gray + A little Cadmium Orange = Slate gray base color

Slate gray base — More Cadmium Orange added to base color

* More water added to base color.

Phthalocyanine Blue + Ultramarine Blue = Cobalt Blue

Cobalt Blue + A little Cadmium Orange = Deep ocean blue base color

Deep ocean blue base — More Cadmium Orange added to base color

* More water added to base color.

* Note: When using gouache or acrylic paints, add white instead of water to lighten value.

These simple, two step surf studies were painted using only the color mixtures shown on the opposite page.

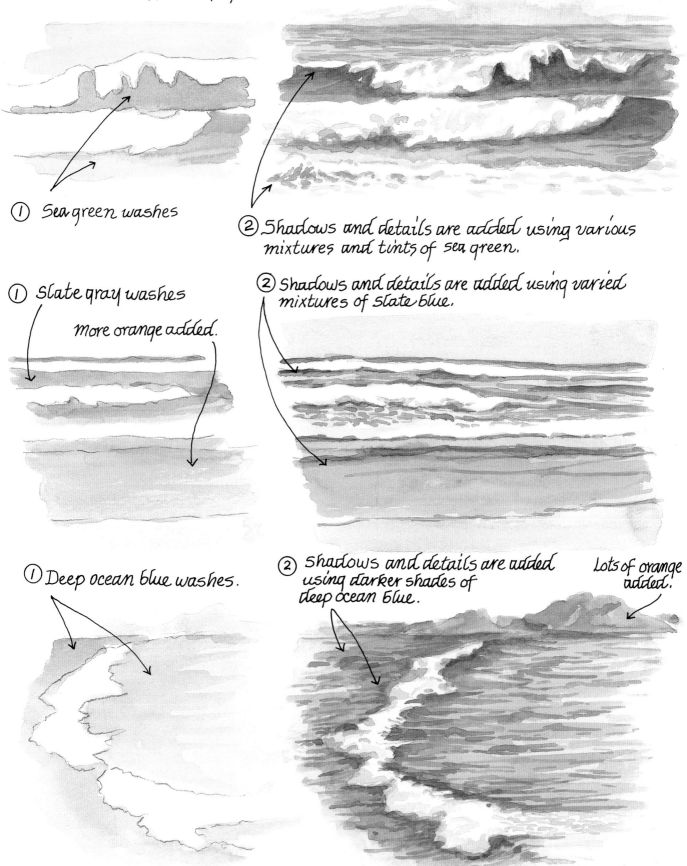

① Sea green washes

② Shadows and details are added using various mixtures and tints of sea green.

① Slate gray washes

More orange added.

② Shadows and details are added using varied mixtures of slate blue.

① Deep ocean blue washes.

② Shadows and details are added using darker shades of deep ocean blue.

Lots of orange added.

Working With Watercolor Glazes

A glaze is a watered-down, thin layer of paint which is applied over a dry, previously painted surface. Glazing can be used to increase the intensity of a colored area or to darken and shade it.

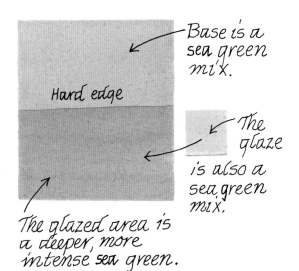

Base is a sea green mix.

Hard edge

The glaze is also a sea green mix.

The glazed area is a deeper, more intense **sea** green.

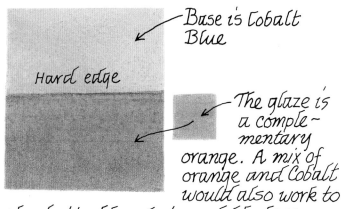

Base is Cobalt Blue

Hard edge

The glaze is a comple-mentary orange. A mix of orange and Cobalt would also work to shade the blue, but would be less striking and require more layers to produce **deep** shadow tones.

A soft, blended edge between the base color and the glaze layer.

A soft, blended edge between the base color and the glaze layer.

To produce a soft, blended edge where the glaze and base color meet, stroke the edge of the _moist_ glaze with a clean, damp (not wet) brush. An appropriate sized flat or round brush works well for this. Re-clean and blot the brush often.

There are two glazes applied to these samples, both with blended edges.

Numerous glazes may be painted over a base color, letting each one dry before adding the next. Keep in mind when using complementary glazes, that each layer will appear grayer.

Ocean Wave Study in Watercolor

Masking shown in blue.

① mask out the small, delicate areas that you wish to remain white. Larger white areas can be painted around. Let dry.

② Paint a pale wash of sea green mix (see page 18) into the colored areas of the wave.

Blended glaze.

③ Mix Cobalt Blue with a little orange to make slate gray. Water it down and apply it to the shaded parts of the white foam areas.

④ Deepen the shaded parts of the sea green wave and remove masking.

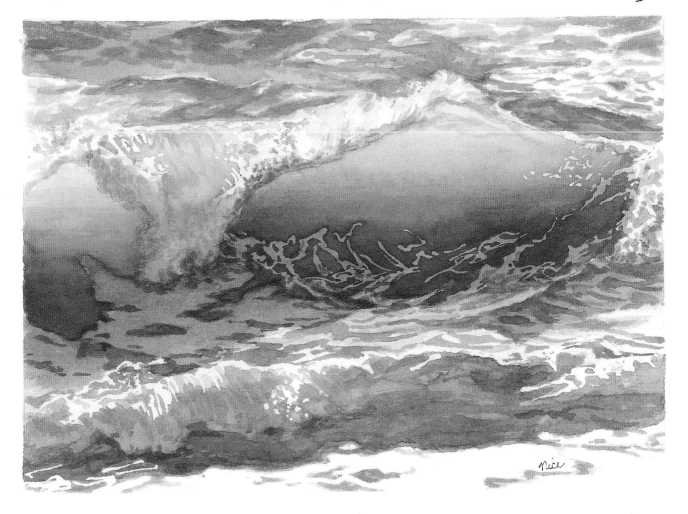

nice

Painting With Gouache

Gouache is a type of watercolor which is opaque, and has a thicker consistency than the standard water color paint. It has the feel of tempera and dries to a matt finish.

Being opaque, light areas of gouache may be painted over dark. However it may take several layers.

A gouache seascape

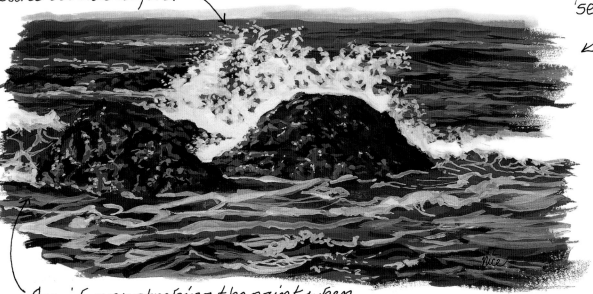

Avoid over-stroking the paint when layering the colors. Gouache will dissolve with moisture and the action of the brush, creating a less striking mid-tone. On the other hand, this can be very useful when one wishes to create the look of water mist or fog, especially over a dry area of watercolor. Thin a puddle of white Gouache with water and blend it in well.

As seen in the watercolor and gouache painting below, raging surf can stir up the ocean floor, discoloring the water and foam.

Mist created by working a wash of white gouache over the dry watercolor.

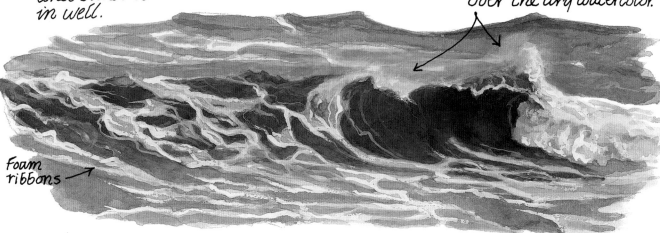

Foam ribbons

Leaving the paper unpainted is always the best way of creating brilliant white areas in a water color painting. However, I love white gouache for adding foam ribbons, water spray and highlight dots to a seascape.

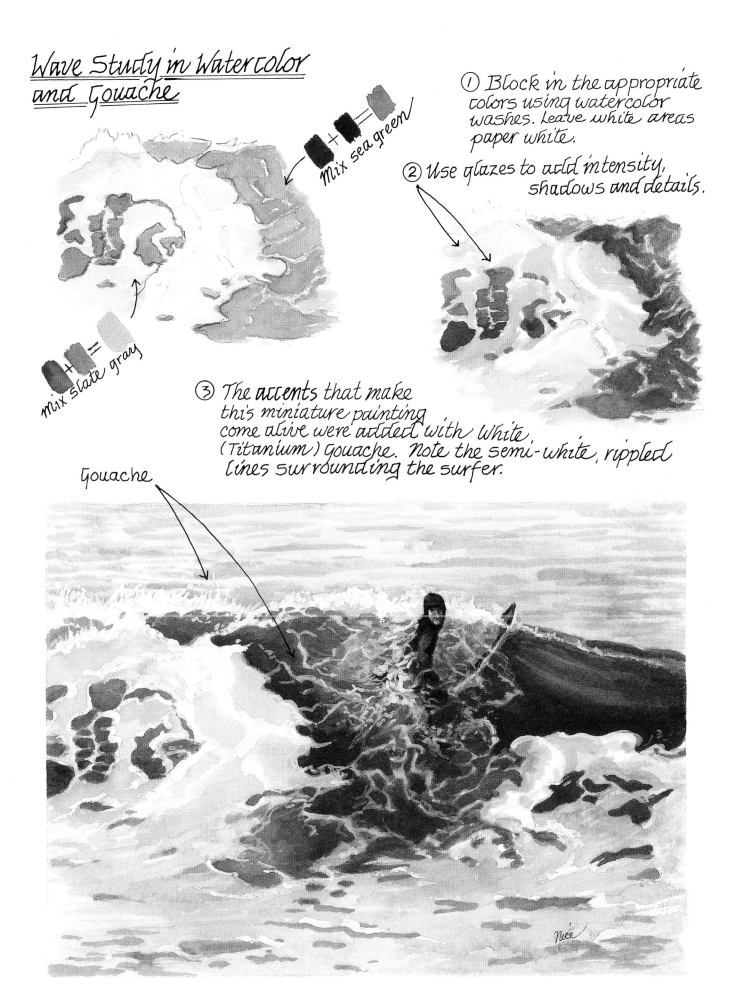

Wave Study in Watercolor and Gouache

① Block in the appropriate colors using watercolor washes. Leave white areas paper white.

② Use glazes to add intensity, shadows and details.

Mix sea green

Mix slate gray

③ The accents that make this miniature painting come alive were added with White (Titanium) Gouache. Note the semi-white, rippled lines surrounding the surfer.

Gouache

Nice

Painting a Surging Sea Swell in Watercolor

① Painting an animated sea swell exploding against an unyielding mass of stone is not difficult, but does require some planning. Begin with a light pencil sketch, indicating where the patches of foam and white water will be. Mask them out with masking fluid. This first step is the most important. The more lacy white areas you create, the more turbulent your sea swell will appear. Make sure foam streamers follow the rise and fall of the swell.

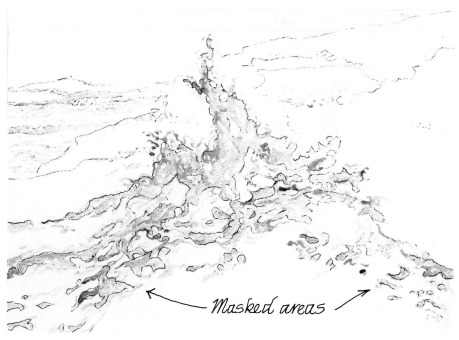

Masked areas

② Create a cloudy sky. I used Cobalt Blue for the sky patches, and Payne's Gray for the clouds, applied wet-on-wet. Lay a base wash of sea green mix (page 18), over the water. Use a flat brush to apply it.

③ When the base wash is dry, glaze over it with a second wash of sea green mix. Leave some of the base wash to show through, especially in the most foamy areas. Let dry.

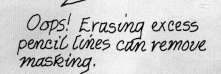

Oops! Erasing excess pencil lines can remove masking.

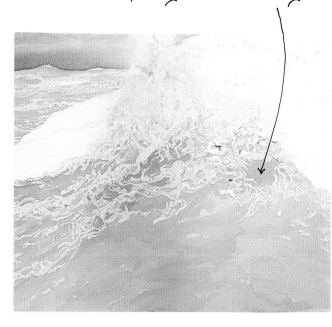

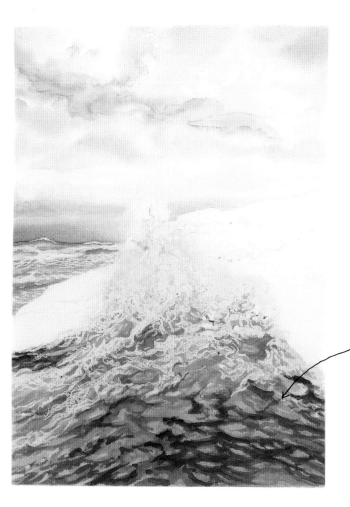

④ Create several more mixtures of sea green. Use slightly less water so they are a little more intense in color. You can vary the mixtures a little bit by adding more red-orange or a touch of Sap Green. Add Payne's Gray to the darkest mix.

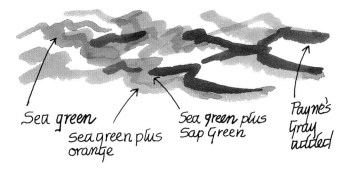

Sea green

sea green plus orange

Sea green plus Sap Green

Payne's Gray added

⑤ Use a round no. 4 brush and glaze loose, shallow wave shapes across the sea swell, working from the lightest tone to the darkest. Work on a dry surface and allow the edges to remain crisp.

⑥ Paint in the rocks. I used Yellow Ochre muted with blue violet for the base color and added Sepia to create the darker glazes. A touch of Cobalt Blue suggests sky reflections. Let dry.

⑦ Remove the masking fluid to reveal the paper-white foam and water spray areas. Use a glaze of very pale sea green to soften white edges that appear too harsh or abrupt, but leave plenty of white froth.

⑧ Apply touches of Titanium white gouache to add droplets to the edge of the swell and wet glisten to the surface of the rocks. The water dripping off the rocks is also painted on with gouache and smeared with a damp brush. Use a round detail brush for these details.

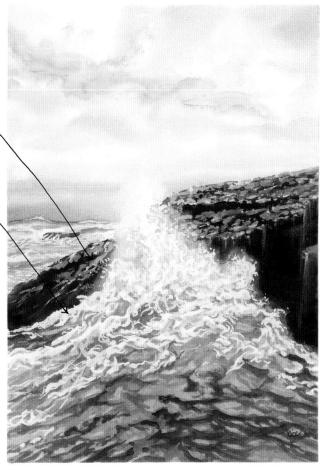

A Surf Study in Acrylics

① Begin by blocking in the mid-value colors. It's OK if it looks rough.

The palette consists of
- Titanium White
- Cobalt Blue
- Phthalo. Blue
- Sap Green
- Cadmium Yellow Lt.
- Cadmium Orange

② Work the deeper shadow colors into the wave structure.

③ Paint in the foamy white areas with White. Mix a touch of Yellow and Sap Green into the White to suggest sunlit, translucent areas. Shade the white water with a mix of Cobalt Blue, Orange and White.

Wind-blown spray.

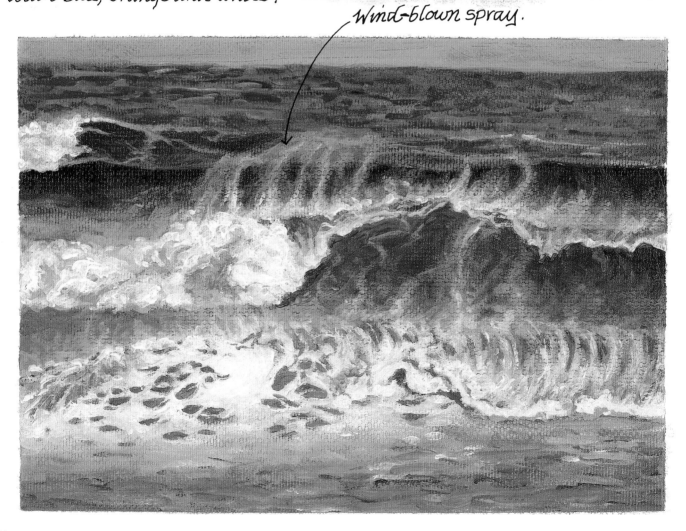

Painting Rocks and White Water in Acrylics

Acrylic paint lends itself well to painting seascapes due to the fact that you can paint flecks of water spray and ribbons of foam right over the darker hues of the rocks and water.

① I began this painting by roughing in the water areas and painting the water spray over the top using Titanium White.

In this painting I used a slightly different color mixture for the water.

Phthalo Blue + Cadmium Red/Orange Mix = Titanium White to lighten color

For variety add Sap Green or Payne's Gray.

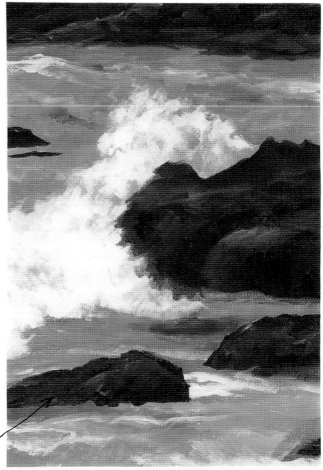

Burnt Umber + Payne's Gray = Neutral Brown (Sepia)

② The rocks were roughed in using the color mixture shown above and a ¼ inch flat brush. Some of the lighter mixtures used to paint the water were brushed across the top of the rocks, plus dabs of red orange and Sap Green. Work Payne's Gray into the crevices and lower parts of the rocks to give them a dimensional form. Leave edges rough and unblended.

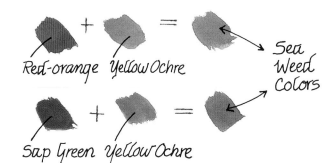

Red-orange + Yellow Ochre = Sea Weed Colors

Sap Green + Yellow Ochre = Sea Weed Colors

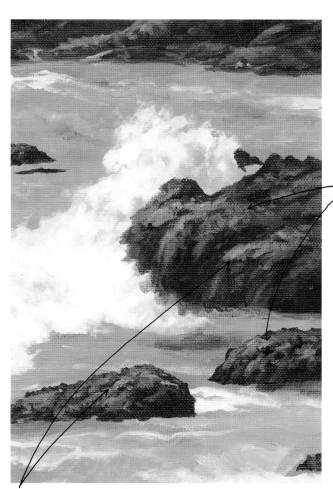

③ The seaweed colors shown above were mixed and daubed loosely across the upper surfaces of the rock to suggest vegetation. Leave the edges of the seaweed patches hard. White, mixed with a little of the blue-green color used to paint the water, was painted on the rocks to suggest reflections.

Water reflections.

④ Shadows, ripples and wave shapes were added to the ocean water using darker versions of the color mixtures shown in step one and a no. 4 round detail brush.

⑤ The last step was to add the final details. Foamy streamers of white were brushed across the surface of the water, and water drops were dabbed in front of the rocks using the point of a no. 4 round brush. The reflection areas on the rocks were also accented with white highlights. Study the finished painting on the opposite page.

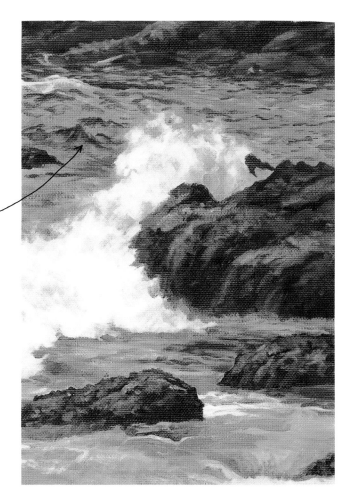

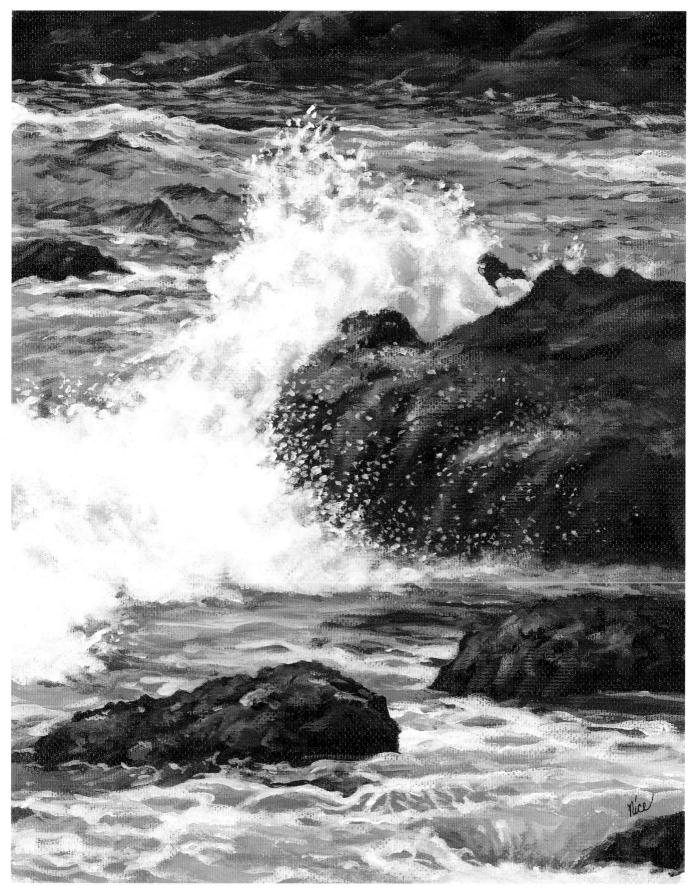

"STORM SURGE AT YAQUINA HEAD" Acrylics, 8 x 10 inches (20 x 25cm)

Seascapes in Pen and Ink

The most important thing to remember when working in pen and ink is to maintain good contrast, light against dark and busy pen lines against open or solid areas.

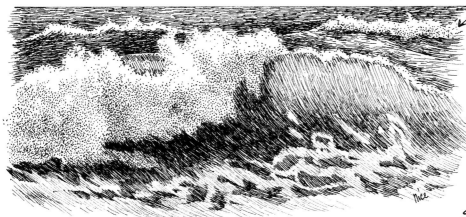

Dots make delicate water spray

Contour lines, those lines which are placed side by side and flow smoothly over a curved surface, are perfect for depicting the action of waves.

Contour lines were used to sketch the smooth surface of this rock.

Scribble lines put energy and the essence of "splash" into crashing white water spray.

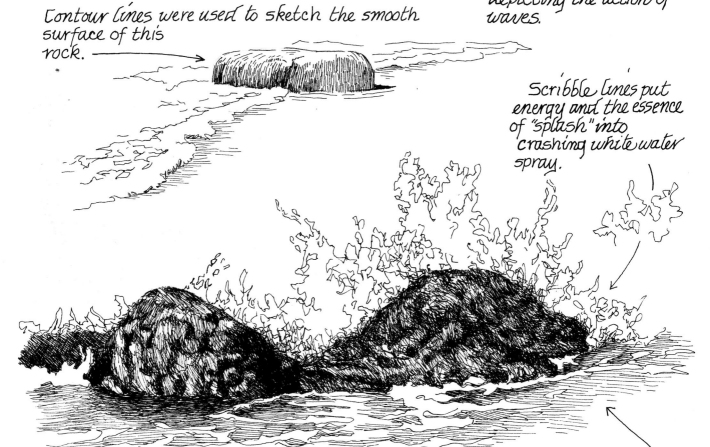

Cross-hatch lines

Scribbly crosshatch lines

Crosshatching works well to suggest rocks with rough contours or those covered with seaweed.

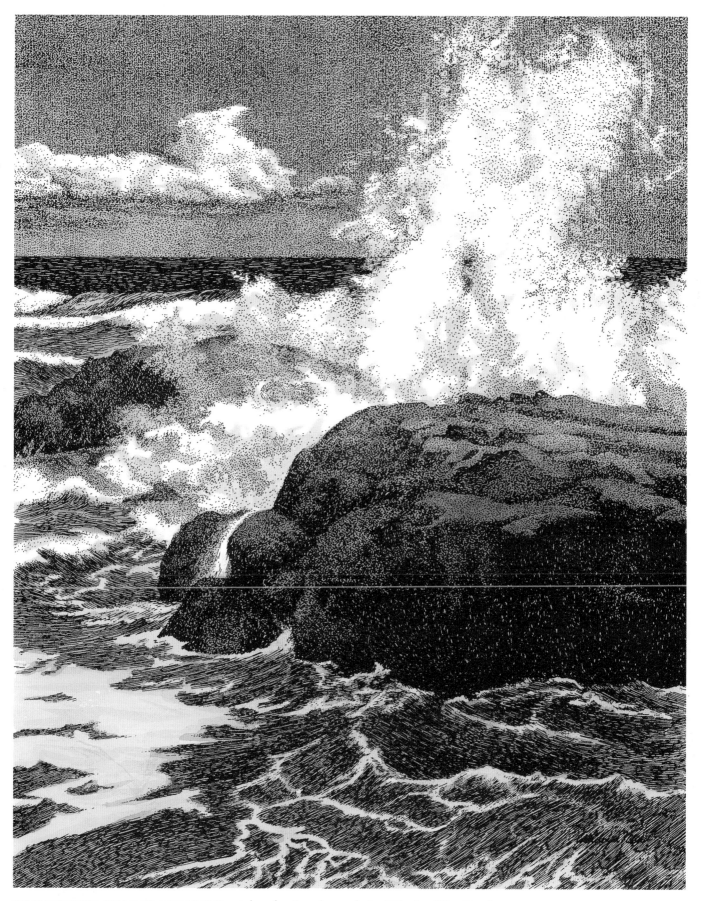

"THE MEETING OF ROCK AND SEA" Pen, ink and watercolor wash, 8 x 10 inches (20 x 25cm)

A finished pen-and-ink drawing, overlaid with watercolor washes, has an antique look similar to an early hand-tinted postcard. Note that dots also work well to texture worn and eroded sea rocks.

Painting Pot Holes in the Sea Foam

The sea churns up a blanket of foam which clings to its surface like melted whip cream floating in a mug of hot chocolate. Blow on the surface and the creamy foam parts to reveal patches of chocolate beneath. These open patches are the pot holes. The sea creates the same effect as it stretches the foam apart to reveal areas of dark water.

① Pencil in the pot holes. They should stretch in the direction the water is moving.

② Paint in the pot holes with a round brush and a wash of water color.

③ Erase the pencil lines

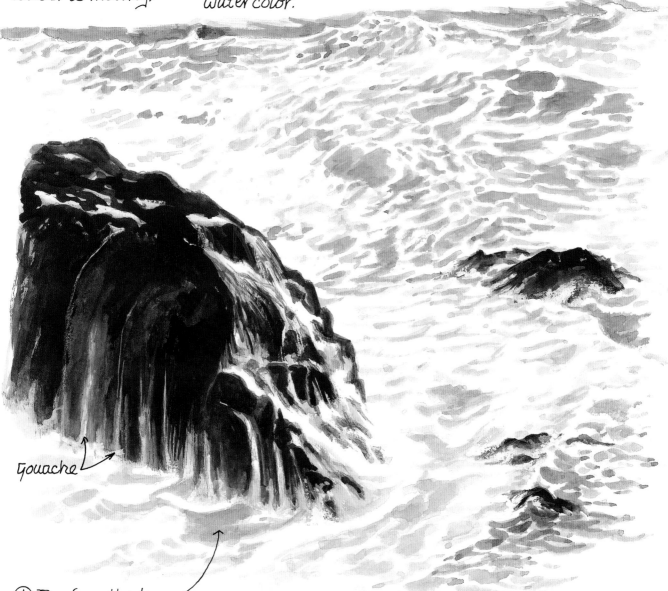

Gouache

④ Darken the tone of the pot holes with glazes where needed.

I used sea green to paint the water, Sepia for the rocks and touches of White Gouache.

Just for fun and Practice

These simple, miniature seascapes are fun to do and make great cards and sketch book journal entries.

This surf scene was painted in two steps. First the water and rock areas were blocked in with pale watercolor washes, then detailed with glazes of the same colors. Use 1/4 inch flat brushes and no. 4 or smaller round brushes.

Deep ocean blue mix (see page 18). Rocks are Sepia. White areas are left unpainted.

A variety of sea color mixes were used to paint the ocean in this scene, starting with Deep ocean blue and adding Phthalo Blue and Azo Yellow in the foreground. The Sepia rocks were tinted with Orange and detailed with a Brown Pitt brush pen and frosted with White gouache.

Paper White

This whole storm-tossed seascape was painted with washes of sea green mix to which extra Cadmium Red Lt. was added. The darker areas are glazed in.

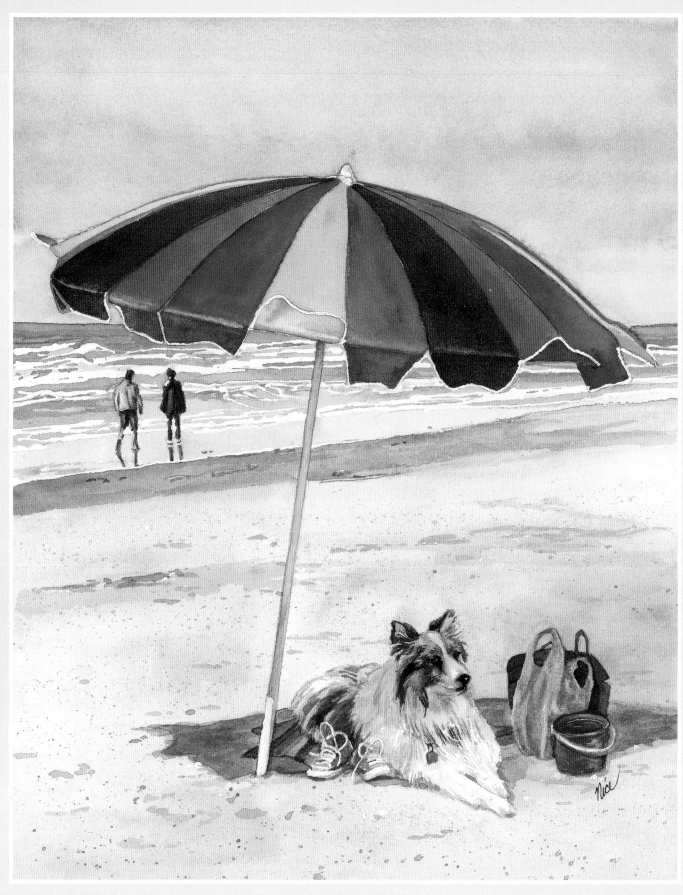

"UNDER THE BEACH UMBRELLA" Watercolor, 8 x 10 inches (20 x 25cm)

2

Sandy Beaches and Sweeping Shorelines

THE BEACH IS ONE OF MY FAVORITE VACATION SPOTS. I love to feel sand between my toes, smell the tangy ocean air and hear the rhythmic roar of the surf. My brushes and pens can't capture the sound and smell of the seashore, but I can set down its color, texture and mood, and maybe hint a little at how the sand would feel if you took off your shoes and stepped into the scene.

Consider the stretch of sand in the watercolor painting on the facing page. The pale color tones are clear and warm, subtly reflecting the bright reds and oranges of the beach umbrella, towel and sand bucket. The shadows and wet sand areas are cool and inviting, echoing the sea green of the ocean in a muted manner. These earthy colors did not result from the haphazard stirring together of palette puddles, which usually produces muddy tones, but by simply combining two complementary colors (red-orange and blue-green). The gritty texture in the foreground was accomplished by flicking a loaded flat brush against the edge of a credit card to produce simple, controlled spatter.

As appealing as the sand and sea are, a good composition needs a focal point to pull the eye of the viewer into the painting. A distinctive shape or spot of color will do. It could be a clump of beach grass, a piece of driftwood, shorebirds or people. Beach figures can add more than vertical shapes and color to the scene; they can help tell the story. The people in the beach umbrella painting are wearing coats, although the day seems bright and sunny. That, and the fact that the scalloped edge of the umbrella is flapping, suggests that this is probably a northern beach, with a nippy breeze blowing.

Although human figures can add great interest to a painting, a fair number of artists exclude them because they have to resemble people, and since we all know what people should look like, there is an abundance of critics. However, if you move those figures into the background, facial features are obscured and details are banished. All you have to worry about is getting their little bodies somewhat in proportion. They can still provide interest and color. In this chapter I will show you how to turn stick figures into properly proportioned beachcombers. The idea will carry through to help you populate cityscapes, country landscapes and sports paintings as well.

Mixing Sand Colors

Sepia plus water provides a neutral sand color.

Although sand is usually pale in color, its exact hue varies according to the rock that produced it. The easiest way to create clean, crisp sand tones is to mix yellow and orange hues with their complementary colors. Add lots of water, or white if you're using opaque paints. The color samples on this page are watercolor.

Yellow + Dioxazine Purple = Violet brown

less purple used in the mixture.

More yellow used in the mixture.

Orange + Cobalt Blue = Blue gray

less blue used in the mixture.

More orange used in the mixture.

Yellow Orange + Ultramarine Blue = Blue gray

Less blue used in the mixture.

More yellow orange used in the mixture.

◊ Additional water was added to these mixtures.

Sand color is a mix of yellow and purple.

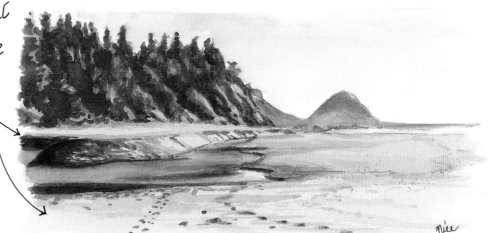

36

Painting Beach Grass

① Begin by masking out the highlighted grass blades. Let it dry. Using a no. 4 round brush, block in the grass with a variety of grayish-green water color washes. Keep it pale.

Masked areas shown in blue.

② Layer on some brighter green mixtures, letting some of the first coat show through.

③ Add the shadows and grass heads using the darkest green mixtures. Remove the masking.

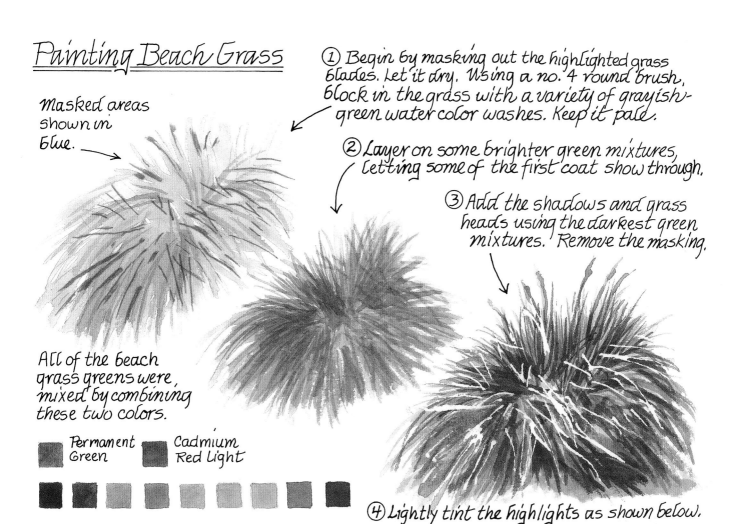

All of the beach grass greens were mixed by combining these two colors.

Permanent Green Cadmium Red Light

④ Lightly tint the highlights as shown below.

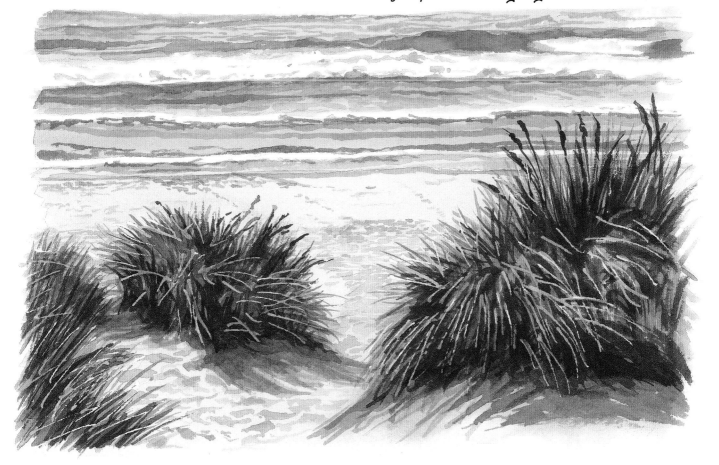

37

Painting Sand Close-up

① Begin with a watercolor wash. Keep it pale, but noticeable. Let it dry.

A mixture of yellow and purple (violet).

A mixture of yellow-orange and blue-violet.

A mixture of Cobalt Blue and orange.

② Add texture by spattering the wash with the same color mixture. Paint of a slightly different color tone may also be used in the spattering procedure but don't vary the value range too greatly.

A fully loaded brush, flicked off a finger tip or credit card, provides a fine, fairly controlled spatter pattern.

Hold ½ inch above paper

Non-spatter areas can be protected with masking fluid or paper cut-outs glued into place with a few dots of masking fluid.

To put white specks in the sand area, spatter masking fluid on before you begin to paint, or spatter white acrylic paint into the sand area. The white flecks seen in the circle above were masked.

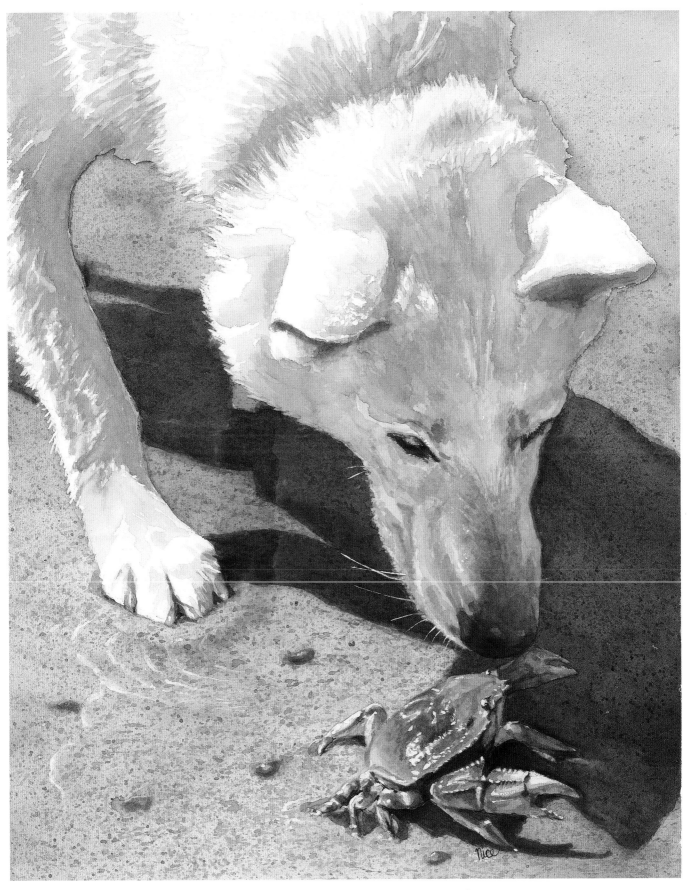

"INVESTIGATING A CRAB" Watercolor with accents of gouache, 8 x 10 inches (20 x 25cm)
White gouache was used to add highlights to the crab and a sheen to the shallow water.

Driftwood

Adding a piece of driftwood to a beach scene can provide some interesting vertical lines and curved shapes.

The texture was added to this watercolor quick sketch using a 1/4 inch wide flat brush and a dry brush technique. Dip the brush in watercolor wash, blot it well on a paper towel and paint.

This sketch was made using a common no. 2 writing pencil. Note how the grain lines follow the curve of the wood.

— Sketched with a .25 nib — (Rapidograph).

Wavy lines

stippling →

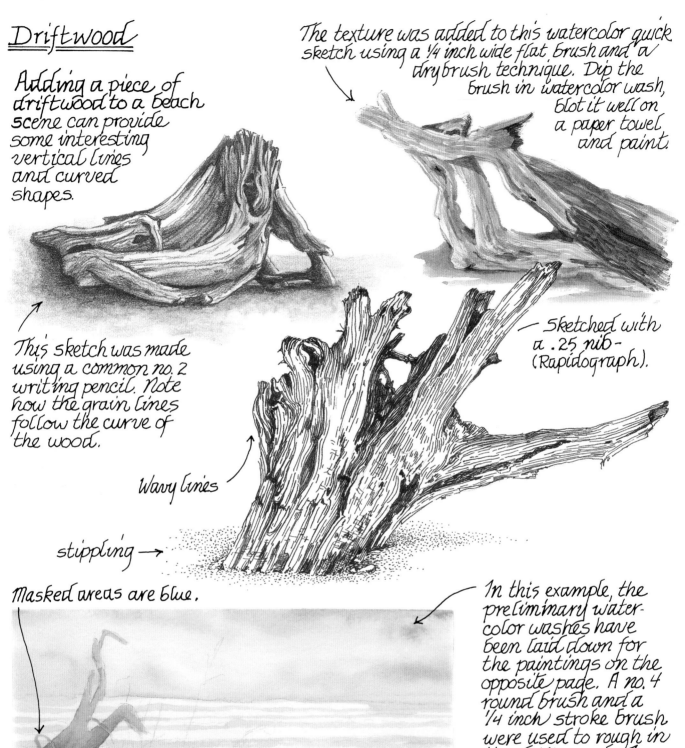

Masked areas are blue.

In this example, the preliminary watercolor washes have been laid down for the paintings on the opposite page. A no. 4 round brush and a 1/4 inch stroke brush were used to rough in the drift wood. I stroked in the direction of the wood grain and did not over-blend the various shades of gray and brown together. Letting the colors flow together naturally forms interesting patterns.

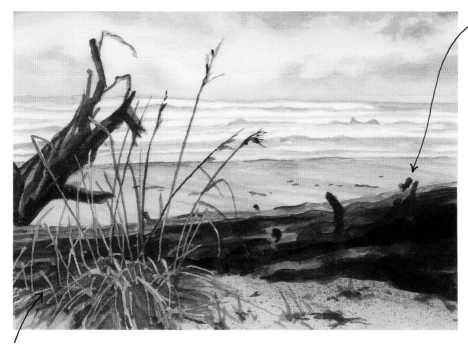

A second layer of darker watercolors (Burnt Umber, Sepia and a Cobalt Blue/Orange mixture) was painted loosely over the logs, giving the driftwood the illusion of both texture and form. I applied the paint over a dry surface using long, quick strokes with the small flat brush. Edges were left crisp. Note that some of the preliminary washes were allowed to show through.

When the painted logs were dry, the masking was removed and the grass blades filled in with a small, round, detail brush and varied shades of green and reddish brown.

Although the painting shown above is a finished watercolor beachscape, the painting below shows how it can be changed by adding a bit of pale lavender-blue acrylic highlight to the drift wood and grasses. It makes the wood look shiny and wet as if it had just rained.

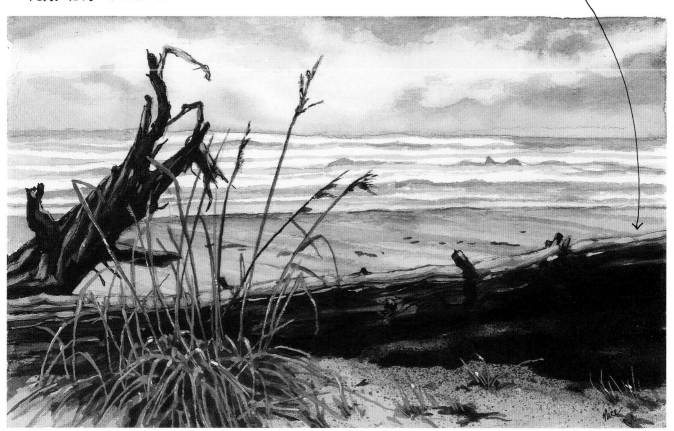

Acrylic Driftwood

1. Begin your painting with a shaded pencil sketch to establish the values. Keep it light.

2. Using a small flat brush, lay the dark areas of the driftwood onto the canvas. On this painting I used a mix of Cobalt Blue and Cadmium Orange. I streaked Burnt Sienna in the more exposed areas for a touch of color.

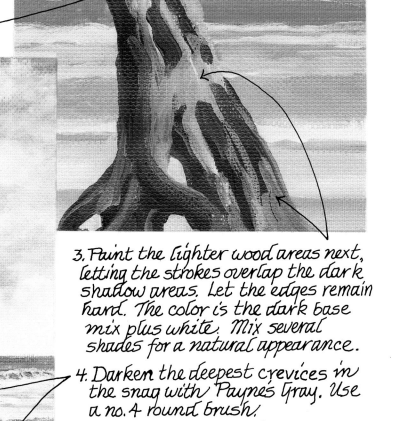

3. Paint the lighter wood areas next, letting the strokes overlap the dark shadow areas. Let the edges remain hard. The color is the dark base mix plus white. Mix several shades for a natural appearance.

4. Darken the deepest crevices in the snag with Payne's Gray. Use a no. 4 round brush.

5. For the final highlights on the driftwood snag, I divided my light paint mixture in half and added a touch more orange to one part, and more blue to the other. More white was added to each paint pile. The result is warm and cool highlight hues. Dab them into place with the round brush. (see opposite page.)

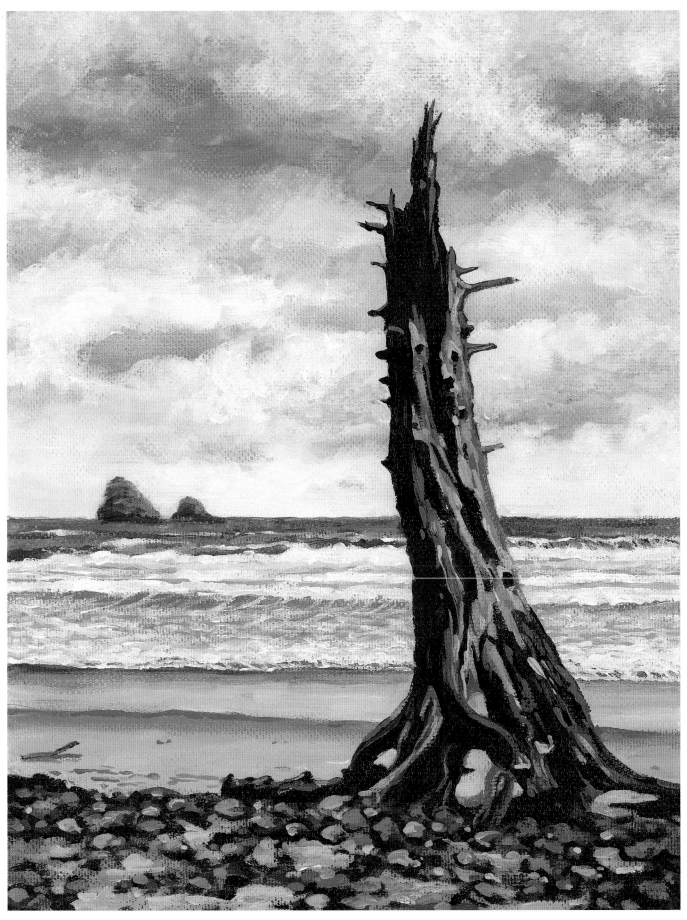

"DRIFTWOOD BEACHSCAPE" Acrylics, 7-1/2 x 9-3/4 inches (19 x 24cm)

Beach Figures from Stick Figures

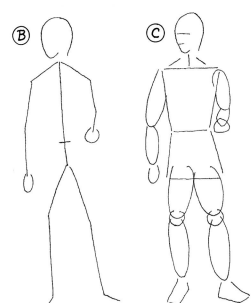

Adding a distant figure or several to your beachscape will provide an area of focus.

Figure (A) shows a sketch of an average adult man. Note from the measurement chart beside him that he is six heads (plus necks) high. His mid-point is half way between his waist and the top of his legs. His arm and hand hang down to where his legs begin.

In figure (B) I have drawn a stick figure to match the proportions shown in figure (A). It's rough, but close enough to form a framework. I have marked the waist (2½ head-and-neck lengths down) with a short horizontal line.

Figure (C) shows a simple but fairly accurate way to round out the stick figure. Use a trapezoid shape to form the chest from the shoulders to the waist. A shorter trapezoid, turned opposite the first one will form the trunk from the waist down. Upper and lower arms and legs can be rounded out using long ellipse shapes. Note that the knee is 1½ head-and-neck lengths from the ground. Wedge shapes form the feet.

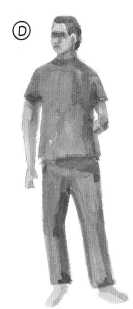

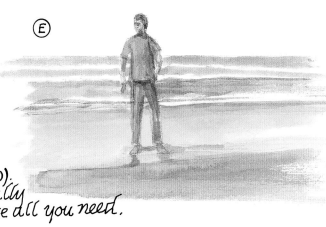

Add some clothes and paint, and you have a beach figure which is proportionally correct (D). Don't add details, especially in the face; shadows are all you need.

Smaller figures show even less detail. A mere shadow across the eyeline is as much detail as you need to suggest a face (E).

Step by step Beach figures

1. Decide how big the figure will be. Mark the space it will fill at the top, middle and bottom.

2. Beside the space you have set aside for your beach figure, lightly pencil in six heads with necks, three above the mid-point and three below. This exercise will help you get the head size in proportion to the body.

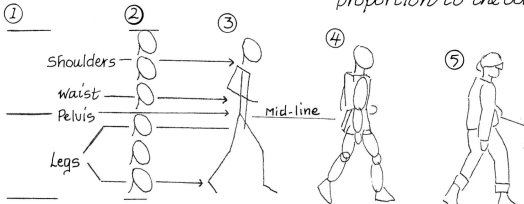

Shoulders
Waist
Pelvis
Legs
Mid-line

3. Draw the stick figure. Keep in mind that the pelvis is located at the mid-point. This is a convenient place to begin the two leg lines. However, when it comes time to round out the body, extend the lower torso ½ a head's length below the mid-point.

5. Add clothes to your beach figure. Keep them plain and simple.

4. Round out the figure using geometric shapes. For a side view, imagine that the trapezoids used to shape the trunk are three-dimensional forms turned sideways.

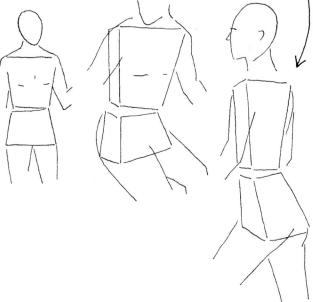

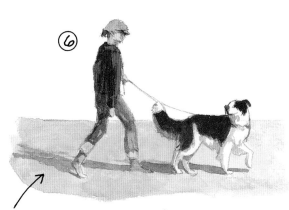

Paint the beach figure using a small, round detail brush, no. 3 or smaller. Keep in mind that the further away the figure is, the more muted the colors will be. Cast shadows will help tie the figure to the ground plane.

Even tiny figures can add a bit of color and interest to a scene.

More Beach Figures

Here are some more distant people to practice drawing. Refer to the previous page for step-by-step directions. Note that painting the figures is a two step process, as shown in the bottom watercolor scene. First the basic color is blocked in (A). The paint is allowed to dry and then shadows are added. Make the shadows crisp and simple.

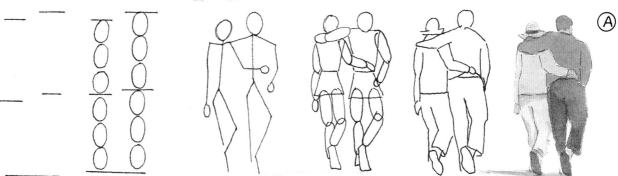

Figures seen at a great distance are suggested with simple, muted, daubs of paint. No shadows. No details.

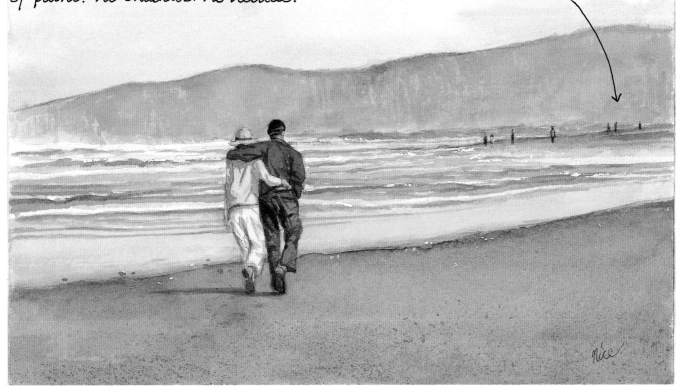

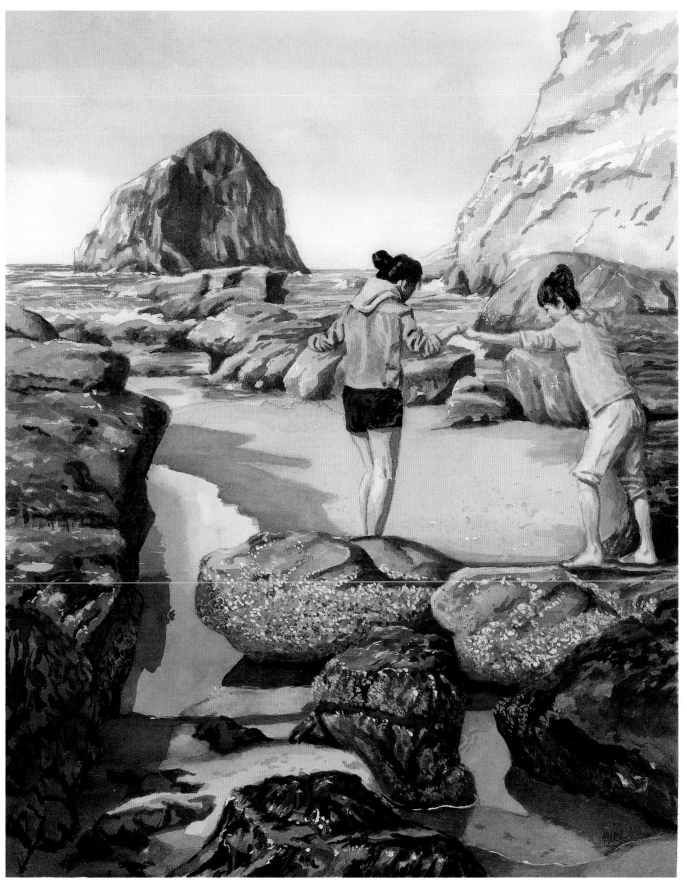

"A HELPING HAND AT LOW TIDE" Watercolor and gouache, 8 x 10 inches (20 x 25cm)
Foreground figures can also be created from stick figures, but more details and value changes need to be shown. Working from photos will help.

Shore Birds

Seagulls, sandpipers and an occasional raven are among the birds that scavenge the surf's edge hunting for tasty morsels. Adding one or more of them to a beach scene can perk up a painting.

1. Most bird bodies can be quickly sketched using an egg shape for the torso, with the wide end at the chest, and an ellipse or oval for the head.

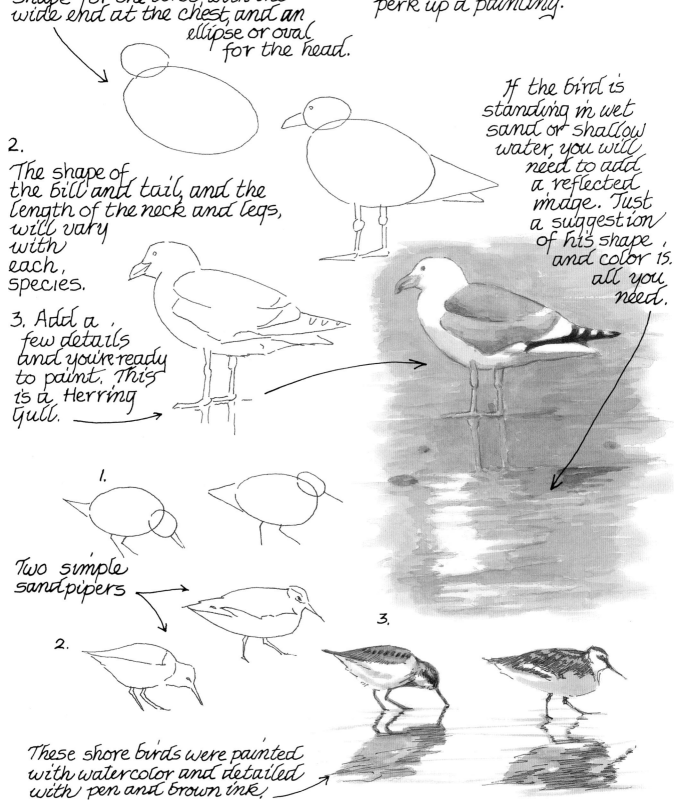

2. The shape of the bill and tail, and the length of the neck and legs, will vary with each species.

3. Add a few details and you're ready to paint. This is a Herring Gull.

If the bird is standing in wet sand or shallow water, you will need to add a reflected image. Just a suggestion of his shape and color is all you need.

1.

Two simple sandpipers

2.

3.

These shore birds were painted with watercolor and detailed with pen and brown ink.

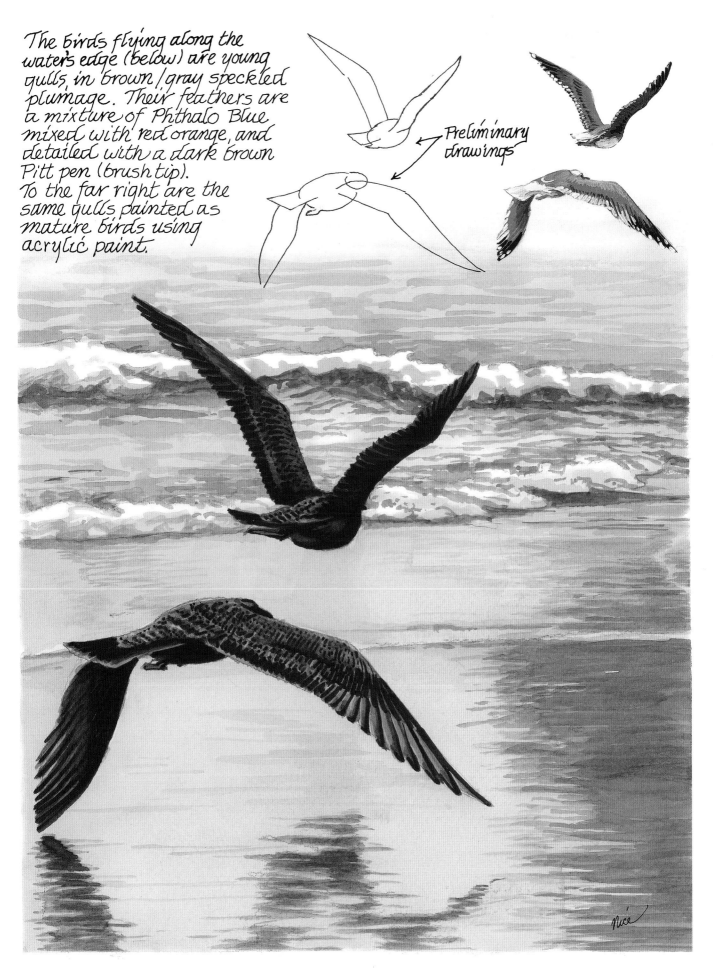

The birds flying along the water's edge (below) are young gulls, in brown/gray speckled plumage. Their feathers are a mixture of Phthalo Blue mixed with red orange, and detailed with a dark brown Pitt pen (brush tip).
To the far right are the same gulls painted as mature birds using acrylic paint.

Preliminary drawings

Nice

Pen and Ink Details

Pen and ink can work well to portray the details and textures of a beach scene or to add the finishing touches to a simple watercolor.

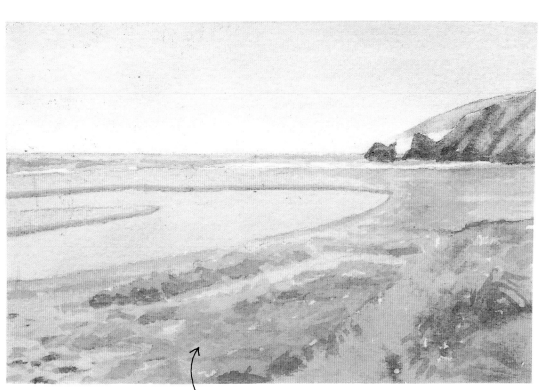

This miniature painting begins with watercolor washes and some shade-work, using the glazing technique.

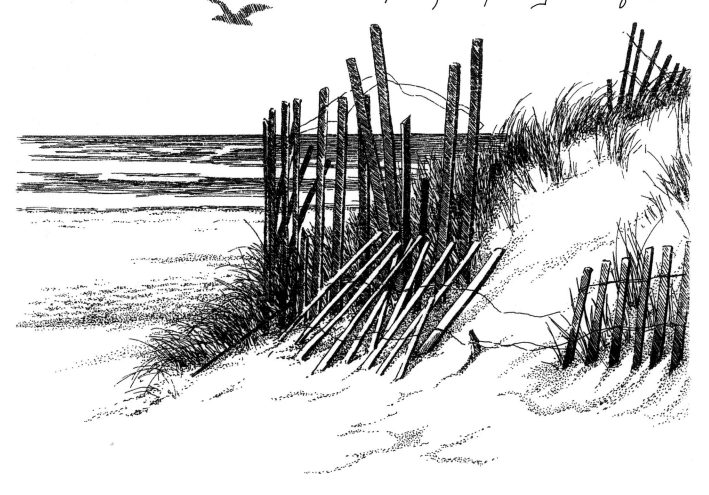

Pitt colored ink pens (brush nibs) and Rapido-graph pens (.25mm) were used to bring out the details in the painting.

Various shades of green and brown colored pens were used on the grasses.

Rapidograph pens were used to texture the teasel weeds.

Touches of acrylic added highlights.

Parallel lines were used to suggest the gull and ocean on the opposite page.

Long criss-cross lines were used for the beach grass.

Dots (stippling) created textured shadows in the sand.

NICE

Just for Fun and Practice

(Watercolor project)

I call this painting LOW TIDE. It depicts a sandy bar, stretching out to where the river flows into the ocean. It began as a thumbnail ink sketch to see if I liked the composition.

Actual size is 8 x 10 inches (20.5 x 25.5 cm.)

Step One: Mix Phthalo Blue and Cobalt Blue. Use a flat brush to lay a pale wash of it across the sky and a watered down mix in the water areas.

Step Two: Paint the beach house using Payne's Gray. The roof is the sky blue mix. Leave the deck and trim unpainted. A round detail brush will work best. The trees are a wash of Sap Green muted with Cadmium Red, Lt. Let dry, then shade the foliage with a glaze of Sap Green / Payne's Gray, using a round no. 4 brush.

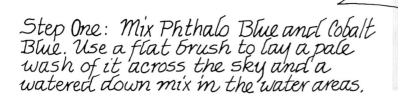

Step Three: Mix a sand color using Phthalo Blue and a red-orange hue, plus lots of water. Paint the sand, rocks and wave ripples as shown above. When dry, do some shade work using the same mixture.

Step Four: Rough in the old pier posts using several "dirty palette" brown mixes and Sepia. Paint the reflections to match, leaving white areas unpainted.

Step Five: Darken the deep water with a glaze of sky color, with a touch of red-orange added.

Step Six: This is my favorite part of the creative process, where the final details, deep shadows and textures are added to bring the painting to life. For the most part the same color mixes are used in the same areas, but less water is used on the palette so the colors are stronger.

In the deep water area, horizontal lines are glazed into place to suggest water movement. As they approach the shore they will curve upward on the right hand side to follow the perspective of the beach. The sand color mix was used to shade the shallow waves in the foreground and the wet sand beneath the rocks.

The posts, their reflections and the piles of rocks surrounding them are detailed with a well blotted no. 4 round brush. Use a mix of Payne's Gray / Sepia for the deepest shadows. Work a little Burnt Sienna and Sap Green into these areas for added color. Leave edges unblended.

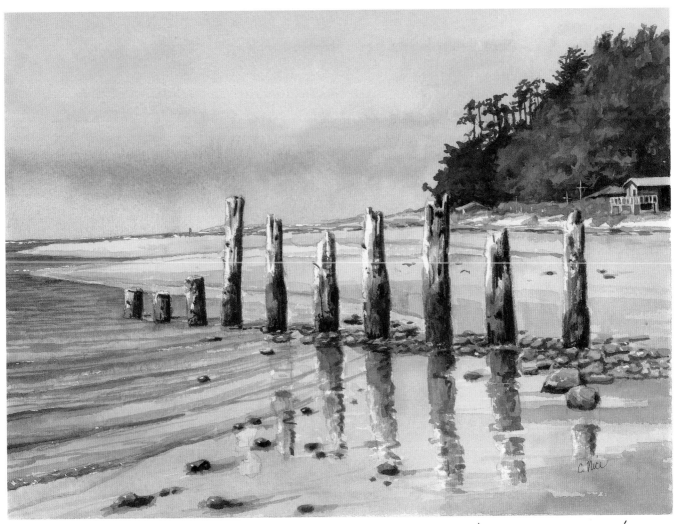

In areas where the highlights needed to be redefined I used white gouache and a small no. 2 round detail brush. Sparkle was added to the foreground waves and rocks, sharp edges were added to the upper right hand sides of the pilings and details were added to the background cottages.

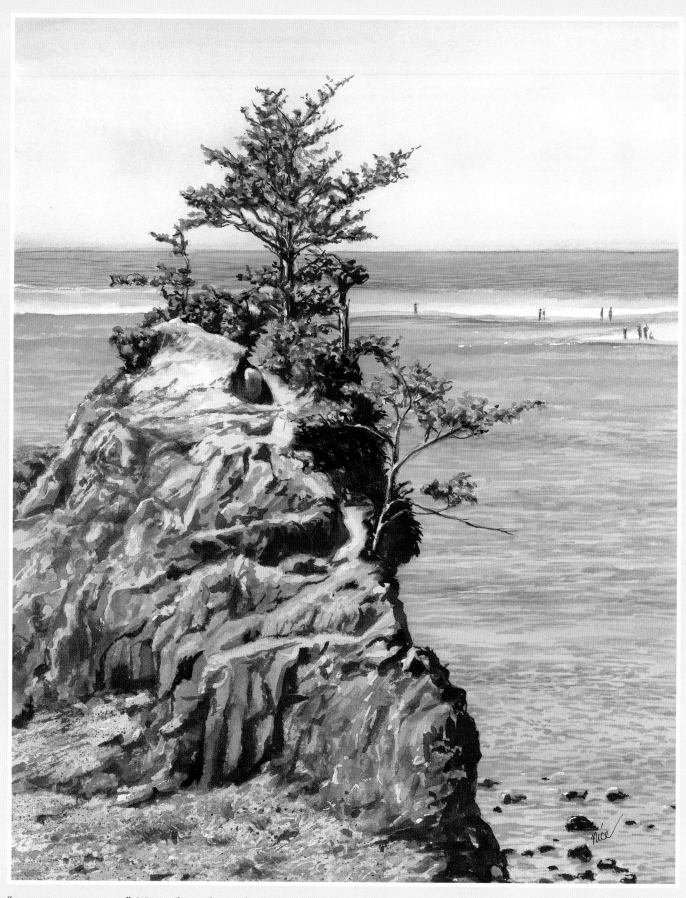

"CASTLE BY THE BAY" Watercolor and gouache, 8 x 10 inches (20 x 25cm)

3

Sea Bluffs and Rocky Coastlines

CONTRAST IS ONE OF THE MOST IMPORTANT ELEMENTS in creating a good composition. The contrast of light against dark, bright against muted hues, and bold busy textures against smooth surfaces, define the forms in an art piece and add drama to the scene. A painting without contrast is about as interesting as a puddle of lukewarm ice cream.

Rock formations protruding out of the translucent waters of the sea and windswept bluffs rising from flat and misty shores, provide some of the best contrasts to be had in coastal scenes. When a mini mountain of stone rears out of the ocean like a marine hay stack, it's called a sea stack. Some sea stacks are far off shore, while others like the one on the facing page, are in the tidal zone. Consider for a moment the contrasts the sea stack brings to the painting.

First there is a contrast of shapes and lines. The rock formation, with its storm-battered trees, lends both a vertical form and a diagonal line to a scene that otherwise would be completely horizontal in design.

The contrast of color is obvious, with the blue of the sea as a backdrop to a complementary range of rusty oranges and peachy-buff hues. The natural orange tones were exaggerated to add pizzazz to the composition.

The deep shadows in the rocks and trees lend all the value contrast to the painting, while the rough stones and leafy shapes provide textural variety.

Now consider what the painting might look like if I had excluded the sea stack and concentrated on the water and sand spit alone. There would be lots of ocean, very little contrast and a great amount of blah!

This chapter explores the shapes, colors and textures of coastal bluffs, and the stone formations that are found in the tidal zone and off shore. With the dab of a brush or the scribble of a pen nib, I will show you how to add the texture of barnacles, mussels and seaweed to foreground rocks, and how to use layering and blotting techniques to produce dense foliage and wisps of fog. If you like to add man-made structures to your drawings and paintings, the last part of this chapter will take you step by step through the mysteries of drawing buildings in proper perspective and how to sketch a towering lighthouse that looks symmetrical.

Creating Cobblestones

To depict a beach of roly-poly cobblestones, one can either form them individually or use the sponge print technique shown below.

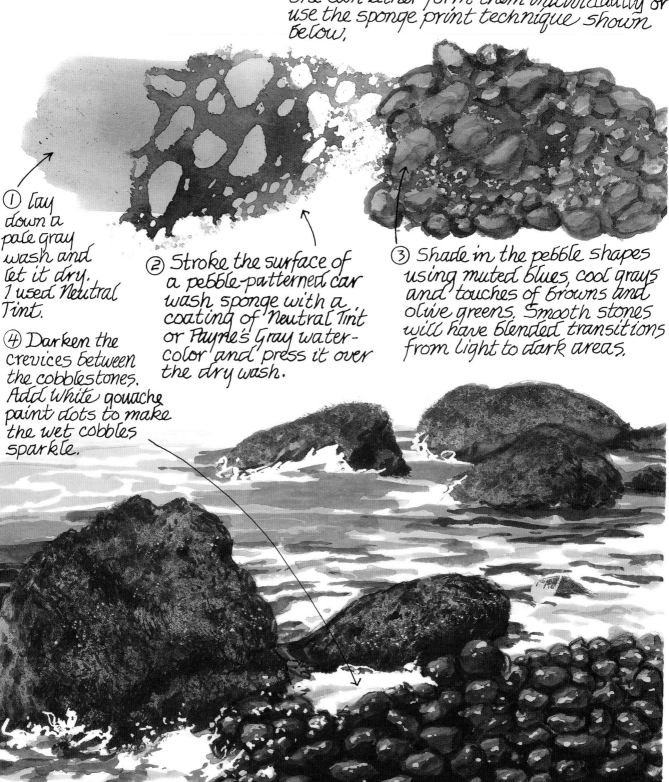

① Lay down a pale gray wash and let it dry. I used Neutral Tint.

② Stroke the surface of a pebble-patterned car wash sponge with a coating of Neutral Tint or Payne's Gray watercolor and press it over the dry wash.

③ Shade in the pebble shapes using muted blues, cool grays and touches of browns and olive greens. Smooth stones will have blended transitions from light to dark areas.

④ Darken the crevices between the cobblestones. Add white gouache paint dots to make the wet cobbles sparkle.

Rough Rock Textures

Rough surface, stationary stones, which are submerged at high tide, become encrusted with seaweed, barnacles and other wild life. Suggesting these craggy textures is just a matter of loosening up your stroke work and adding a few spontaneous touches. Here are some texturing ideas. I used all of them while painting the rough rocks shown on the opposite page.

Layered watercolor washes, each layer applied to a dry surface.

Edges were left hard.

A flat brush was used, well blotted. (Dry brushing).

Colored ink work (PITT, brush nibbed pens).

Stippled with the end of a small flat brush.

Water spattered into a wet wash.

Scribble and crosshatched ink lines (.25 mm nib).

Paper shield in place

This rock was textured with brush spatter (see page 38). The background area was protected with a paper cutout shield, held in place with bits of masking tape.

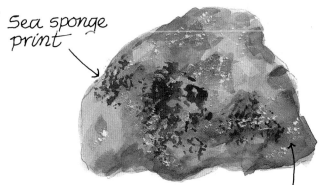

Sea sponge print

Razor scrapes suggest colonies of barnacles. Rough surfaces do not produce bright, reflective highlights but wet patches may glisten.

Appropriate colors for these encrusted rocks include earthy browns, grays, ochres and olives.

Painting a Sea Stack

Rugged, tidal sea stacks with their many crumbling layers look complicated, but painting them is not hard. Just take it step-by-step.

① Begin with a light pencil sketch, then block in the preliminary watercolor washes.

The sky and sea are Cobalt Blue mixed with Phthalo. Blue and a touch of orange. (Add more water to the sky wash).

The foliage is Sap Green with a touch of yellow, orange or red-orange added for variety.

② mask out the lightest areas of the rock formation and dot in some masked highlights in the gravel and foliage areas (shown in bright blue).

③ Glaze some mid-tone value colors into the tree and rock areas. I used basically the same color mixtures, plus some muted oranges and yellow oranges in the sea stack.

The sand spit and sea stack are roughed in with a very pale wash of yellow muted with Dioxazine Purple. Let it dry, then block in the darkest shadow areas with the same mix, with more purple added.

④ Mix Sap Green with a little Payne's Gray. Use a no. 4 round brush to tap in some delicate, shade work on the underside and right side of the tree branches. The trees should look sparse and uneven. Use straight Payne's Gray and the very tip of the round brush to add slender branches and rugged trunks.

⑤ Make some short, vertical dashes on the sand. Use muted colors and don't try to draw people, just wispy lines. If you don't fuss too much with them, your mind will see them as human figures and they will add interest to another wise plain, straight sand bar.

⑥ It's time to remove the masking and see how it looks. This is best accomplished by rubbing the masked areas gently with a piece of masking tape wound around your fingers, sticky side up. Don't tap straight up and down as the paper may pull away with the paint and rubbery mask. Just a gentle side-ways motion works best. The white or pastel areas left behind will look very sharp edged. That is alright.

⑦ The water needs some horizontal wave lines to suggest gentle tidal ripples. Use the no. 4 round brush and the same blue mixture used in step one, with slightly less water added. The lines should not undulate too much, nor should they be a great deal brighter than the back-ground color. Adding a little more orange to the blue mix will create a blue-gray hue that will suggest a shallow area.

⑧ Add some points of brighter color to the rock formation by dabbing on some orange mixed with Burnt Sienna. You can add some touches of Sap Green also to suggest grass and weeds. Use the larger painting shown on page 54 as a visual guide. Use a small flat brush and the drybrush technique to add a bit of pale color at the edge of some of the high lighted patches, but leave plenty of pale rock peeking through.

⑨ I put away the watercolors and mixed up some Sap Green plus Lemon Yellow gouache. The bright opaque paint really perked up the foliage when dabbed on sparingly.

⑩ To create a deep, rich shadow color I mixed Dioxazine Purple with Cadmium Orange gouache and applied as shown to the rocks and dark tree branches. A paler, watered down mix was spattered into the gravel.

Misty Bluffs

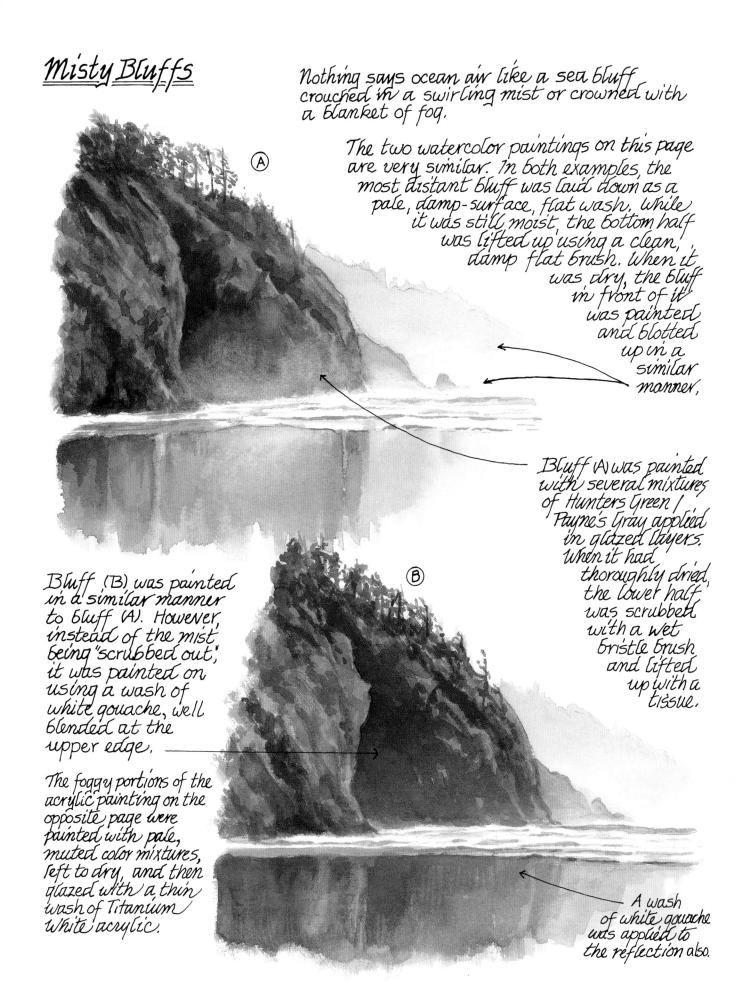

Nothing says ocean air like a sea bluff crouched in a swirling mist or crowned with a blanket of fog.

The two watercolor paintings on this page are very similar. In both examples, the most distant bluff was laid down as a pale, damp-surface, flat wash. While it was still moist, the bottom half was lifted up using a clean, damp flat brush. When it was dry, the bluff in front of it was painted and blotted up in a similar manner.

Bluff (A) was painted with several mixtures of Hunters Green / Payne's Gray applied in glazed layers. When it had thoroughly dried, the lower half was scrubbed with a wet bristle brush and lifted up with a tissue.

Bluff (B) was painted in a similar manner to bluff (A). However, instead of the mist being "scrubbed out", it was painted on using a wash of white gouache, well blended at the upper edge.

The foggy portions of the acrylic painting on the opposite page were painted with pale, muted color mixtures, left to dry, and then glazed with a thin wash of Titanium white acrylic.

A wash of white gouache was applied to the reflection also.

"FOG-CROWNED BEACH BLUFF" Acrylics, 8 x 10 inches (20 x 25cm)

Off-Shore Rock Formations

Distant sea stacks, rising boldly out of the ocean, provide the artist with perfect vertical shapes to add interest to a bland horizon line.

Payne's Gray and Ultramarine Blue, mixed together, thinned with water, and applied with a flat brush. ⟶

The sea stacks are a mixture of Phthalo Blue and Cadmium Red Lt. ⟶

The ocean color is a mixture of Phthalo Blue and Green, muted with red-orange and watered down.

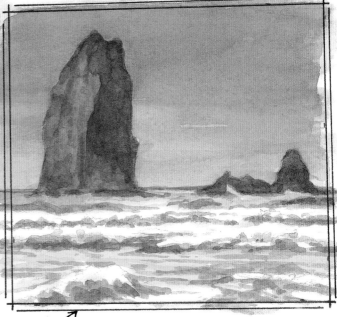

① This miniature watercolor scene began with washes of muted colors.

Sea stacks look awesome silhouetted against a sunset background.

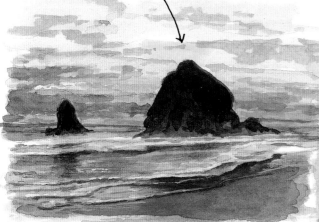

Short, parallel ink lines

Rapidograph pen sketch - nib size . 25 mm.

② The same color mixtures were used as in step one, to glaze on shadows and simple details. After adding a second glazed layer of Payne's Gray / Ultramarine to the top half of the sky, it was brushed with a very thin layer of muted blue-green. The result is a stormy, brooding sky.

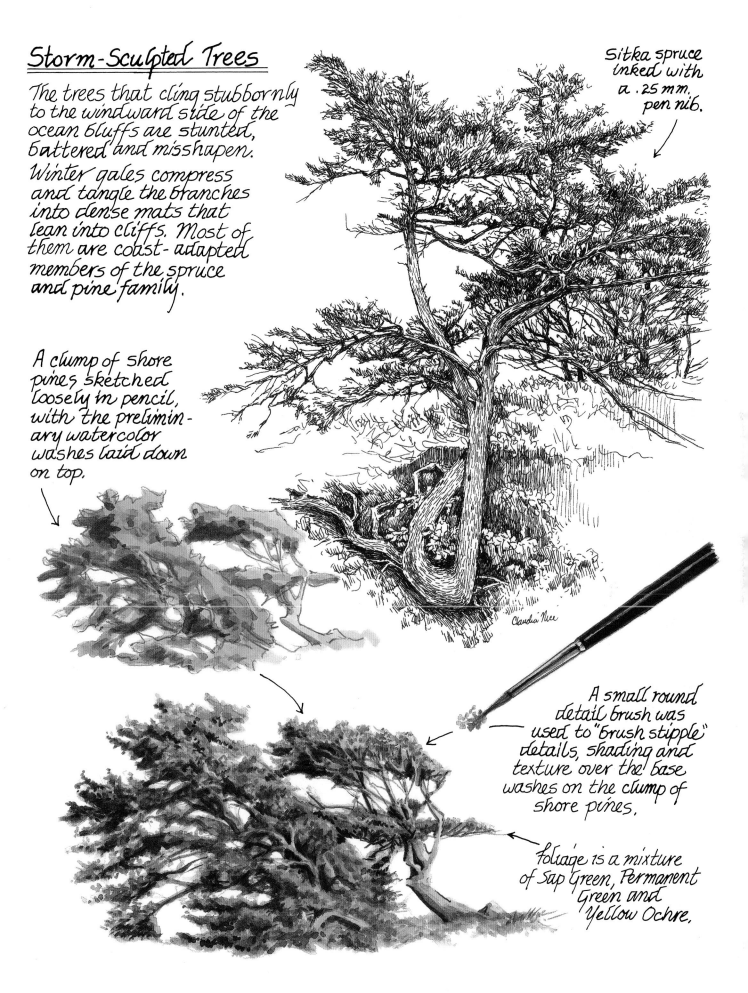

Storm-Sculpted Trees

The trees that cling stubbornly to the windward side of the ocean bluffs are stunted, battered and misshapen.

Winter gales compress and tangle the branches into dense mats that lean into cliffs. Most of them are coast-adapted members of the spruce and pine family.

A clump of shore pines sketched loosely in pencil, with the preliminary watercolor washes laid down on top.

Sitka spruce inked with a .25 mm pen nib.

Claudia Nice

A small round detail brush was used to "brush stipple" details, shading and texture over the base washes on the clump of shore pines.

Foliage is a mixture of Sap Green, Permanent Green and Yellow Ochre.

In this mixed media painting, entitled "Clinging to Life," I used a .25 and .35mm Rapidograph pen to detail and emphasize the ruggedness of the shore pines. Scribble lines and crosshatching were used to texture the tangled undergrowth.

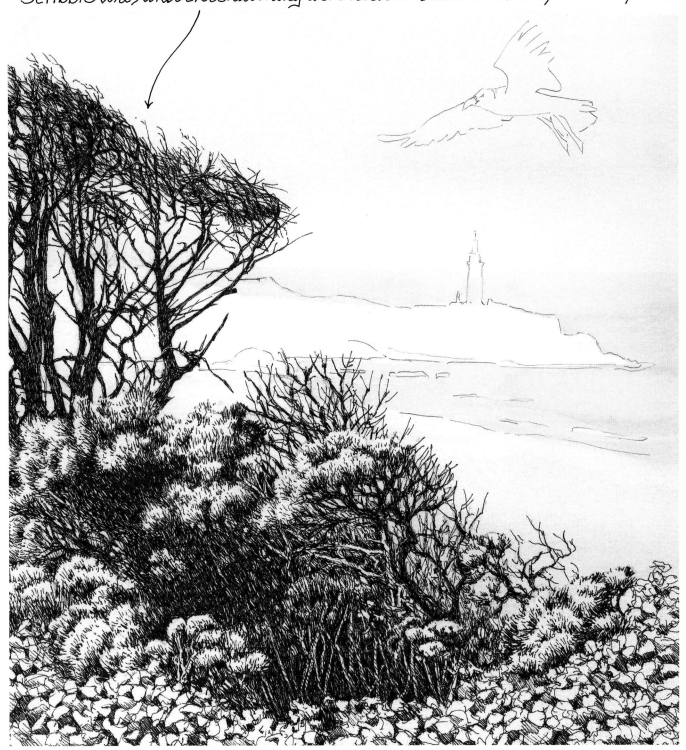

In contrast to the bold pen and ink work, I used washes of watercolor to paint a foggy translucent background, and to brighten the foliage in the foreground. The seagull provides a balance of both form and color. The greens reflect off its underside with a bit of artistic exaggeration (opposite page).

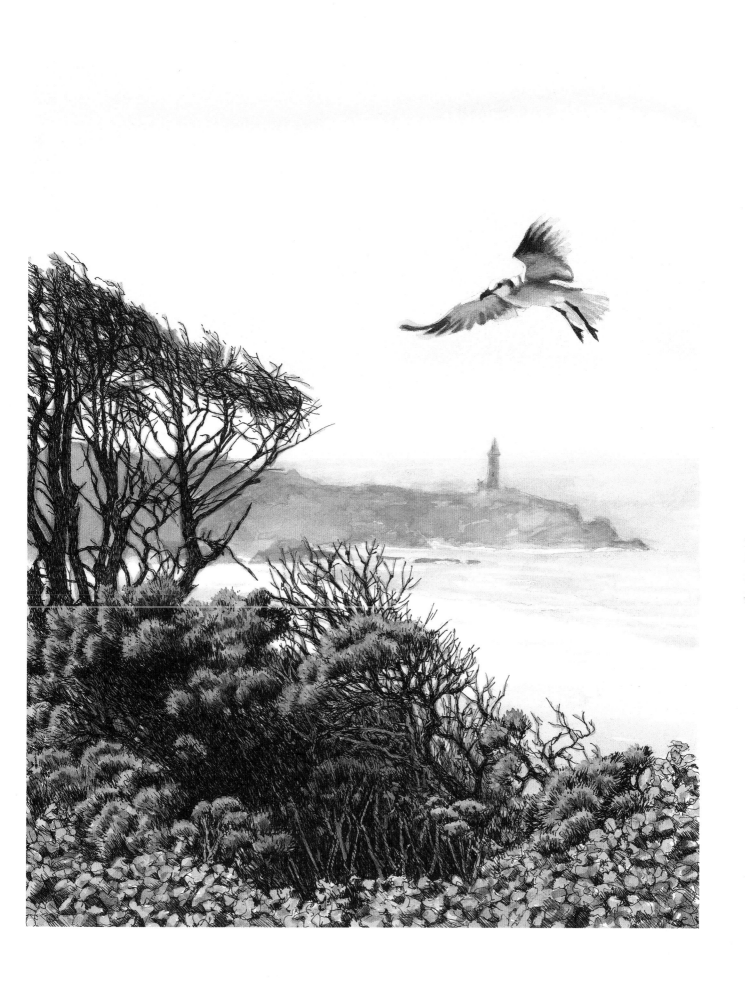

Perspective

Perspective is the technique of depicting dimensional objects on a flat surface.

① The horizon line is located at the eye level of the one viewing the actual scene. The viewer will look up to subjects above eye level (A) and down upon those below it (C). Subjects located at eye level (B) are viewed straight on. The artist needs to keep the subjects true to his point of view as he sketches or paints them, remembering that there is only one horizon line (eye level) per composition and all the objects within that composition must relate properly to it to avoid confusion.

Oblique vanishing point

Vanishing points

Vanishing point

Eye level

Horizon

② Objects appear to grow smaller as they recede into the distance, disappearing altogether at a "vanishing point" located somewhere along the horizon line.

③ Horizontal lines that run parallel to each other, like the roof ridge, the foundation, and the tops and bottoms of rectangular windows, will appear to move closer together as they recede away from the viewer. If extended, the lines should converge on the horizon line at a single vanishing point. Each visible side of a building or cube will have its own vanishing point.

If the parallel lines, shown in perspective, do not converge at the appropriate vanishing point, then the building is out of perspective. This rule is very helpful in finding and correcting mistakes in freehand structure drawings.

④ Diagonal lines drawn to the corners of a rectangular wall can be used to determine the center as seen in perspective. A line drawn up through the center will provide an accurate ridge for the peak of the gable. The pitch of the roof depends on the height of the ridge line.

⑤ Sets of parallel lines that do not correspond to a horizontal ground plane, like the same-side angles of gable (D & E), have an oblique vanishing point. To find the oblique vanishing point relating to the pitch of the roof, run a line upward along the near side of the gable (D). Next locate the vanishing point for the side of the building showing the complete gable (B), and extend it vertically. Where the two lines cross is the oblique vanishing point. Use it as a pivot point to plot the angle of the back gable (E).

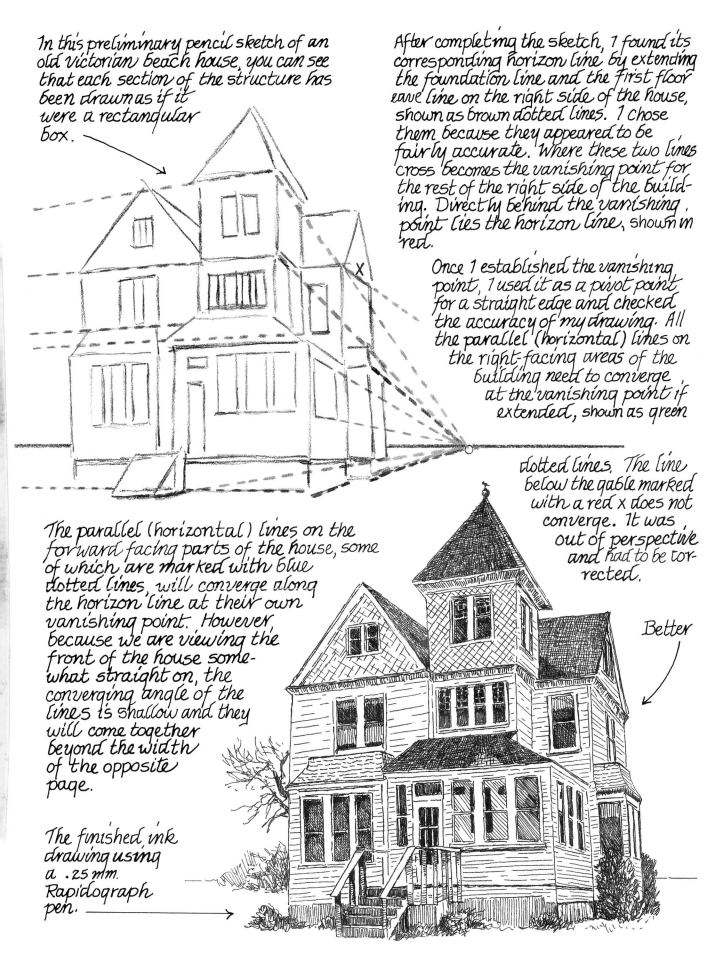

In this preliminary pencil sketch of an old Victorian beach house, you can see that each section of the structure has been drawn as if it were a rectangular box.

After completing the sketch, I found its corresponding horizon line by extending the foundation line and the first floor eave line on the right side of the house, shown as brown dotted lines. I chose them because they appeared to be fairly accurate. Where these two lines cross becomes the vanishing point for the rest of the right side of the building. Directly behind the vanishing point lies the horizon line, shown in red.

Once I established the vanishing point, I used it as a pivot point for a straight edge and checked the accuracy of my drawing. All the parallel (horizontal) lines on the right-facing areas of the building need to converge at the vanishing point if extended, shown as green

X

dotted lines. The line below the gable marked with a red x does not converge. It was out of perspective and had to be corrected.

Better

The parallel (horizontal) lines on the forward facing parts of the house, some of which are marked with blue dotted lines, will converge along the horizon line at their own vanishing point. However, because we are viewing the front of the house somewhat straight on, the converging angle of the lines is shallow and they will come together beyond the width of the opposite page.

The finished ink drawing using a .25 mm. Rapidograph pen.

Beach Houses

This beach cottage sits on a bluff overlooking the Pacific Ocean. Note that the eye level is very low in the composition because the viewer is looking up to the building.

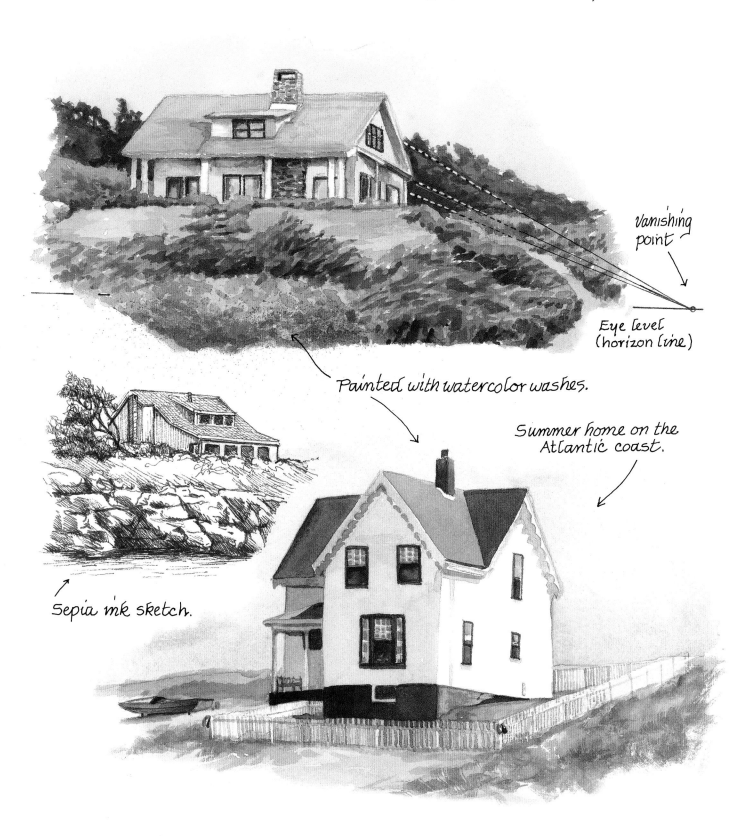

vanishing point

Eye level (horizon line)

Painted with watercolor washes.

Summer home on the Atlantic coast.

Sepia ink sketch.

Lighthouses

Most lighthouses are symmetrical in form. Here's an easy way to make sure they come out even on both sides when drawn!

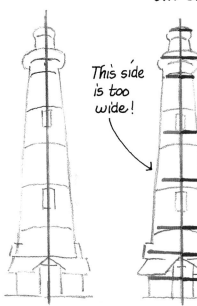

This side is too wide!

Corrections are made and the lighthouse is symmetrical.

① Make a preliminary pencil sketch. Draw a vertical line through the exact midpoint (shown in blue).

② Choose the side of the building which appears to be the most correct. Draw a few horizontal guide lines from the center to the outer edge (shown in red). Duplicate them on the opposite side, matching their length precisely. These lines are shown in purple. They should touch the outer edge in the same manner as the red lines. If not, make the necessary changes.

Brodie Island Lighthouse, Outer Banks, North Carolina

Painted with gouache.

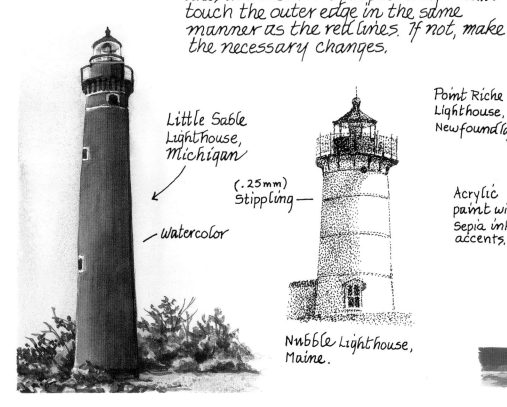

Little Sable Lighthouse, Michigan

Watercolor

(.25mm) Stippling

Nubble Lighthouse, Maine.

Point Riche Lighthouse, Newfoundland

Acrylic paint with sepia ink accents.

69

This is the Cape Meares Lighthouse on the Oregon coast. The mini watercolor project began by laying down the palest color in each area. At that point the sky and ocean were finished. The water has just a touch of orange added to the Cobalt sky color, but not enough to make a sharp tonal change on the horizon.

The dark areas of the building are a mix of Phthalo. Blue and Payne's Gray.

The glass lamp is muted shades of sea green (see page 18).

The foliage is a mixture of Sap Greens, Permanent Greens and whatever else was handy as pre-mixed colors on my palette.

As the preliminary washes dried, I darkened the original puddles of paint on my palette by adding their complementary color, and added mid-tones and shadows to the painting.

The last step was to add the really dark shadows and the details that give form and life to the scene.

Gouache was used to refine the window frame surrounding the lamp and a blue shine on the roof.

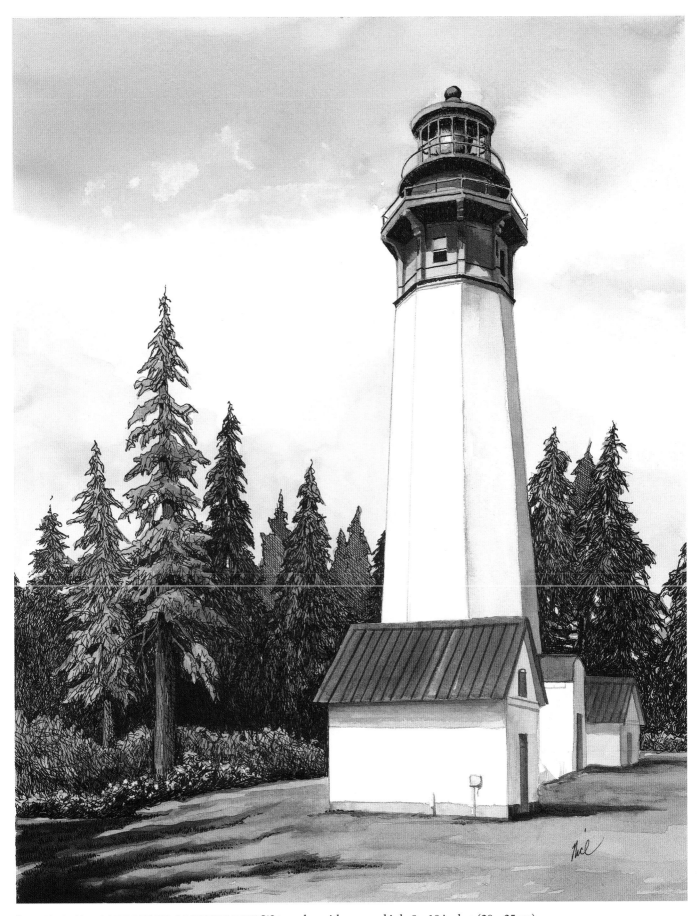

"WESTPORT, WASHINGTON, LIGHTHOUSE" Watercolor with pen and ink, 8 x 10 inches (20 x 25cm)

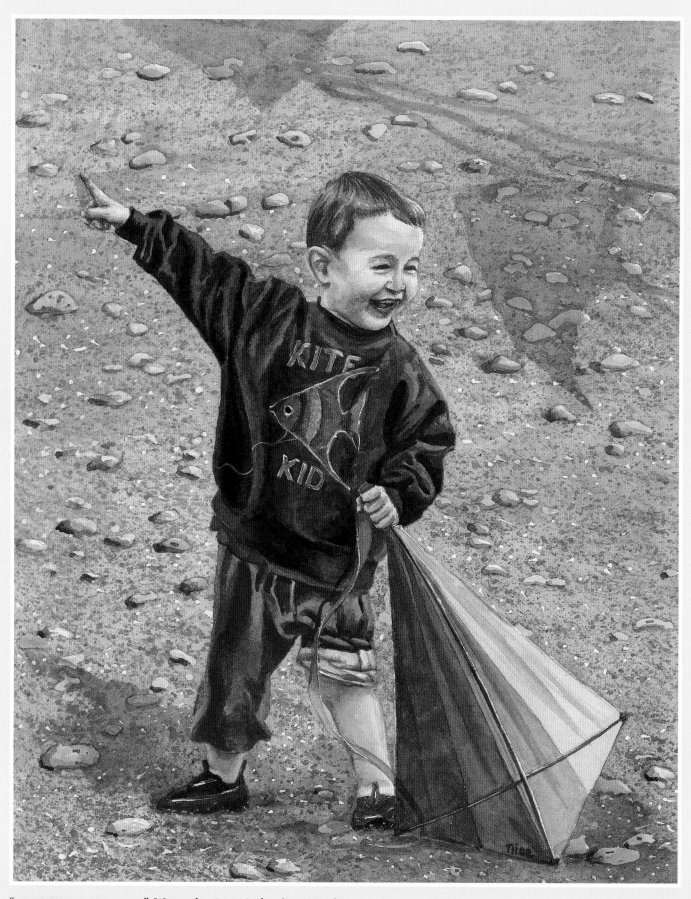

"AT THE KITE FESTIVAL" Watercolor, 8 x 10 inches (20 x 25cm)

4 Fun in the Sun— Children at the Seashore

HERE THEY COME, THE BEACH-LOVING CHILDREN, toting colorful pails, shovels and a variety of sand toys. Their faces are animated with excitement. Their feet, shod in sneakers or sandals, skip about, eager to be set free to bound over the warm sand and feel the cool kiss of the ocean. Childish shouts of joy and squeals of discovery blend into the roar of the surf, to complete the sounds of an afternoon at the seashore.

Soon holes will appear up and down the beach as shovels scoop up mounds of moist sand and small hands form them into castle walls. Games will begin and balls will fly over sunbathers, to be chased by laughing children and barking dogs. At the waterline, where the waves taunt the dry sand, toddlers hold tight to the hands of older family members and learn the thrill of jumping over foam edged ripples.

In the imagination of childhood, sand dollars become pirate treasure and sticks of driftwood become the swords with which to defend it. Can you see them having fun in your mind's eye? This chapter is about seeing the seashore through the eyes of a child and preserving it in the form of art.

Consider the little boy in the watercolor painting on the facing page. We can't see what he is pointing to, but we can guess from the shadows cast on the sand that he is seeing kites. From the excitement on his face, we know that he thinks they are wonderful. His thrill of discovery is contagious, making the viewer happy too. I smiled a lot as I painted the children, dogs and toys in this chapter. It brought back good memories. Painting children need not be any more intimidating than jumping those little ripples at the edge of the sea. It may look scary at first but it can be lots of fun. Come on! I'll hold your hand and show you how.

Drawing Children

Young children have significantly different body proportions than that of adults. Their heads are large compared to the rest of the body, taking up approximately one fourth of the length of the frame. As the child grows, the legs lengthen until the head takes up only about a sixth of the height at age seven.

The heads of babies and infants are fairly round in shape, with the facial features located in the lower half of the face.

Seven year old-
(six heads tall)

Three year old-
(four heads tall)

Eyebrows are half way down the face.

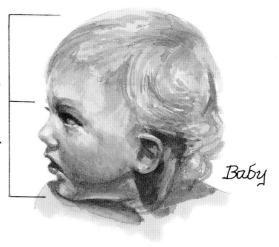

Baby

Ten year old.

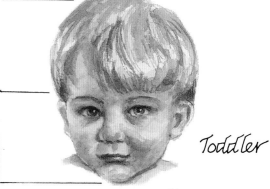

Toddler

The eyes of a toddler are large compared to the other facial features.

By the time a child reaches the pre-teen years, the jaw has lengthened to accommodate adult teeth and the eyes become the mid-point of the face.

These children were sketched from photographs I took, since active kids don't hold still for long. Here are the steps I took to sketch them.

1. Study the subject. How big is the head compared to the rest of the body. Considering the position the child is posed in, how many heads are equal to his height. Knowing this will help keep the head and body in proportion to each other. Mark the head and body size on the paper lightly in pencil.

This boy is two and a half heads high in this pose.

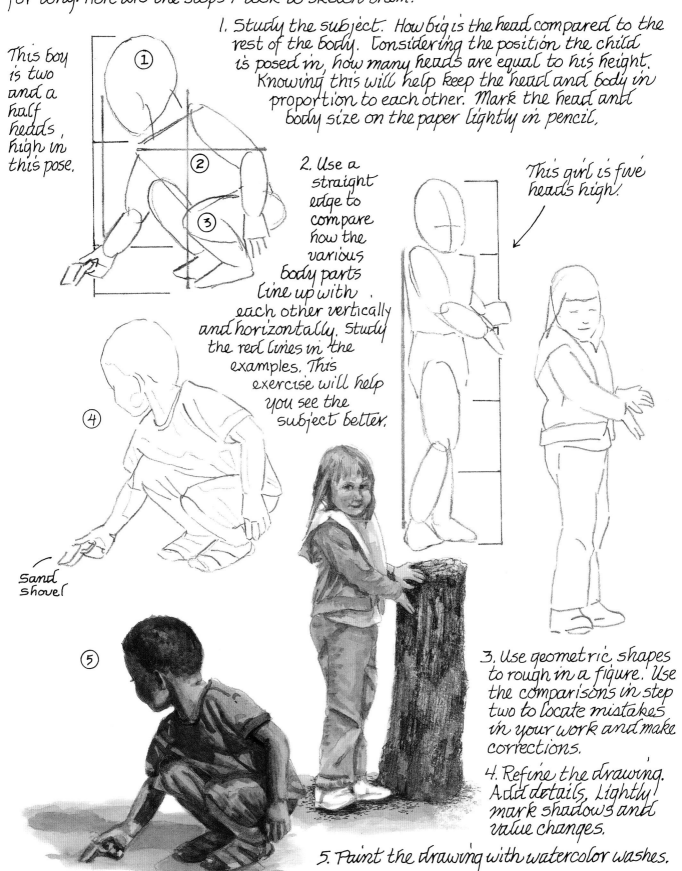

① ② ③

This girl is five heads high!

2. Use a straight edge to compare how the various body parts line up with each other vertically and horizontally. Study the red lines in the examples. This exercise will help you see the subject better.

④

⑤

Sand shovel

3. Use geometric shapes to rough in a figure. Use the comparisons in step two to locate mistakes in your work and make corrections.

4. Refine the drawing. Add details. Lightly mark shadows and value changes.

5. Paint the drawing with watercolor washes.

Skin Tones

My favorite mixture for producing clear, bright Caucasian skin colors begins with Burnt Sienna. Quinacridone Rose is added for a nice, healthy glow, and a touch of green, the complement to reddish brown, mutes the mix to a believable shade. Add lots of water, shown on the top row of each color graph, to lighten the hue.

Base | Blush tones | Skin color | Shadows ⟶

Burnt Sienna + Rose + Permanent Green

More green and less water was added to produce shadow shades.

The graphs shown below are warm and cool variants of the basic skin color mixture. Only the third hue in the mix is changed. The result is skin tones which work well for a variety of races and lighting situations.

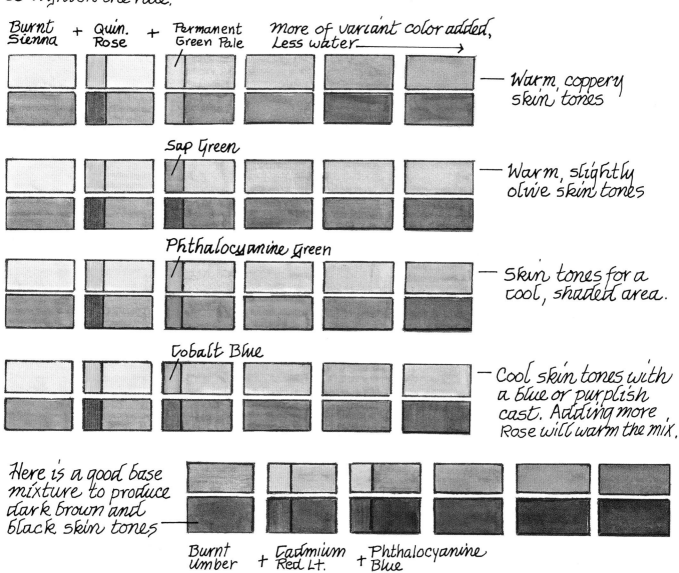

Burnt Sienna + Quin. Rose + Permanent Green Pale

More of variant color added, less water ⟶

— Warm, coppery skin tones

Sap Green

— Warm, slightly olive skin tones

Phthalocyanine Green

— Skin tones for a cool, shaded area.

Cobalt Blue

— Cool skin tones with a blue or purplish cast. Adding more Rose will warm the mix.

Here is a good base mixture to produce dark brown and black skin tones

Burnt Umber + Cadmium Red Lt. + Phthalocyanine Blue

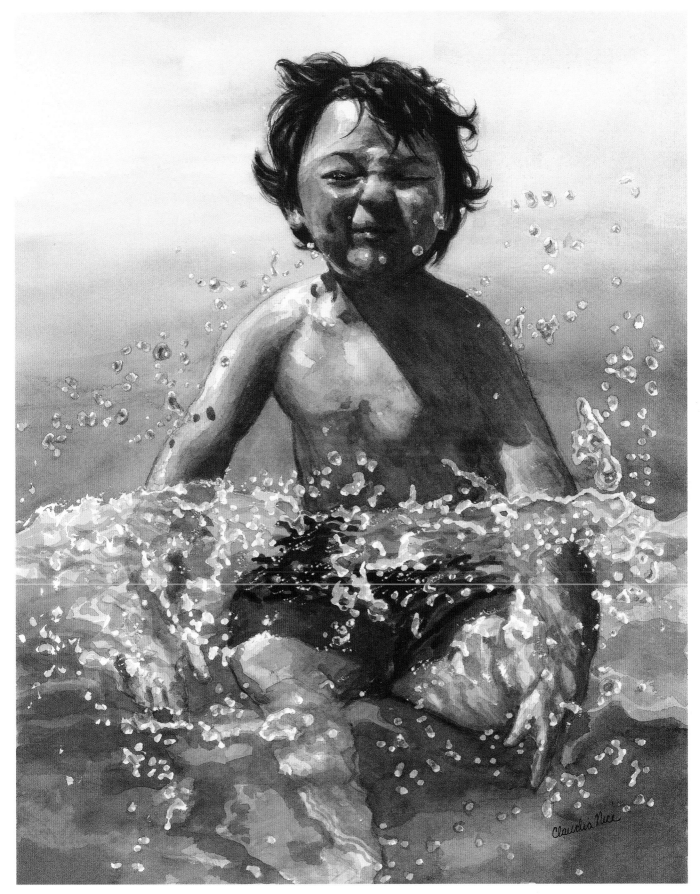

"SPLASH" Watercolor, 8 x 10 inches (20 x 25cm)
Reflections play a large part in the tone of the skin. I chose to use the cool skin tones with the Cobalt Blue variant color because of the amount of blue in the water surrounding the boy.

Little Faces - Step-by-Step

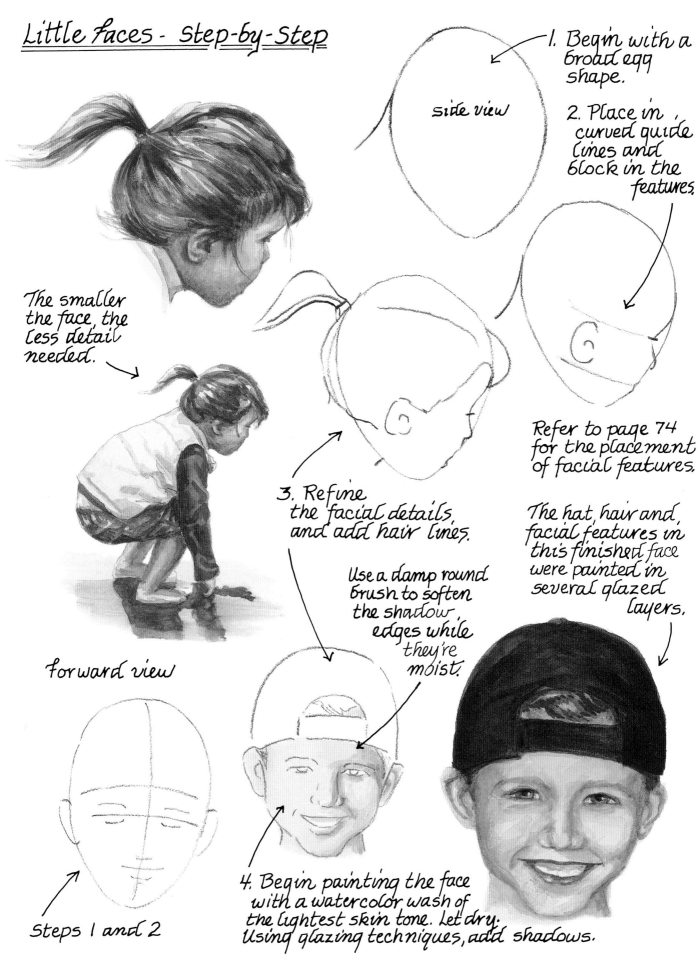

1. Begin with a broad egg shape.

side view

2. Place in curved guide lines and block in the features.

The smaller the face, the less detail needed.

Refer to page 74 for the placement of facial features.

3. Refine the facial details, and add hair lines.

The hat, hair and facial features in this finished face were painted in several glazed layers.

Use a damp round brush to soften the shadow edges while they're moist.

forward view

4. Begin painting the face with a watercolor wash of the lightest skin tone. Let dry. Using glazing techniques, add shadows.

Steps 1 and 2

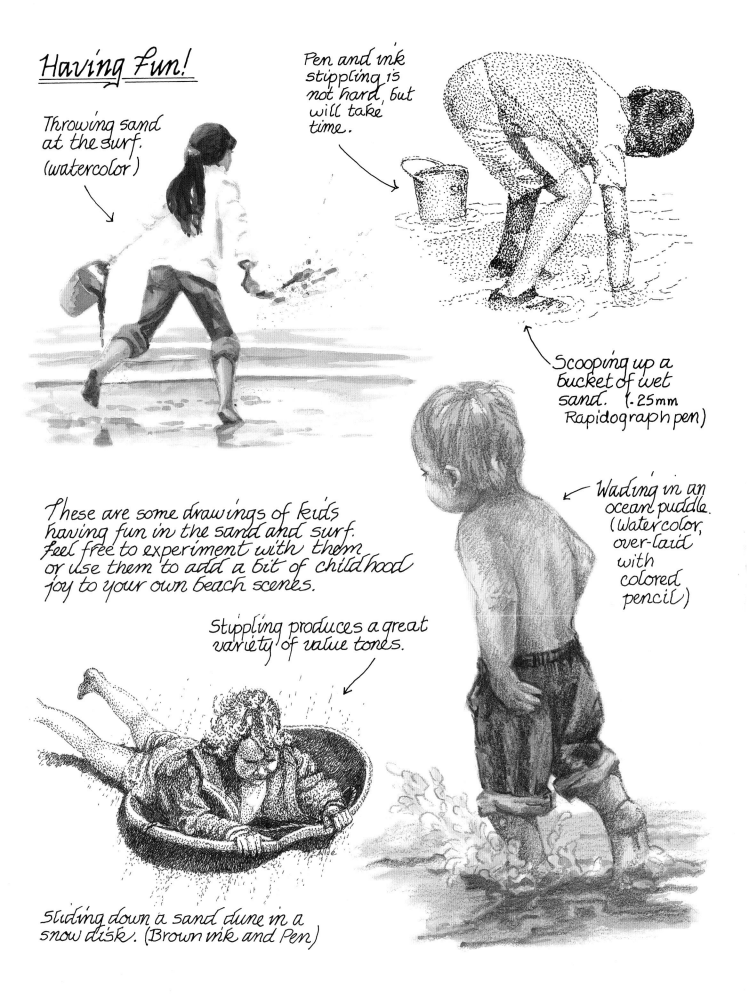

Having Fun!

Throwing sand at the surf. (watercolor)

Pen and ink stippling is not hard, but will take time.

Scooping up a bucket of wet sand. (.25mm Rapidograph pen)

These are some drawings of kids having fun in the sand and surf. Feel free to experiment with them or use them to add a bit of childhood joy to your own beach scenes.

Wading in an ocean puddle. (Watercolor, over-laid with colored pencil)

Stippling produces a great variety of value tones.

Sliding down a sand dune in a snow disk. (Brown ink and Pen)

Painting Hoodies and Blue Jeans

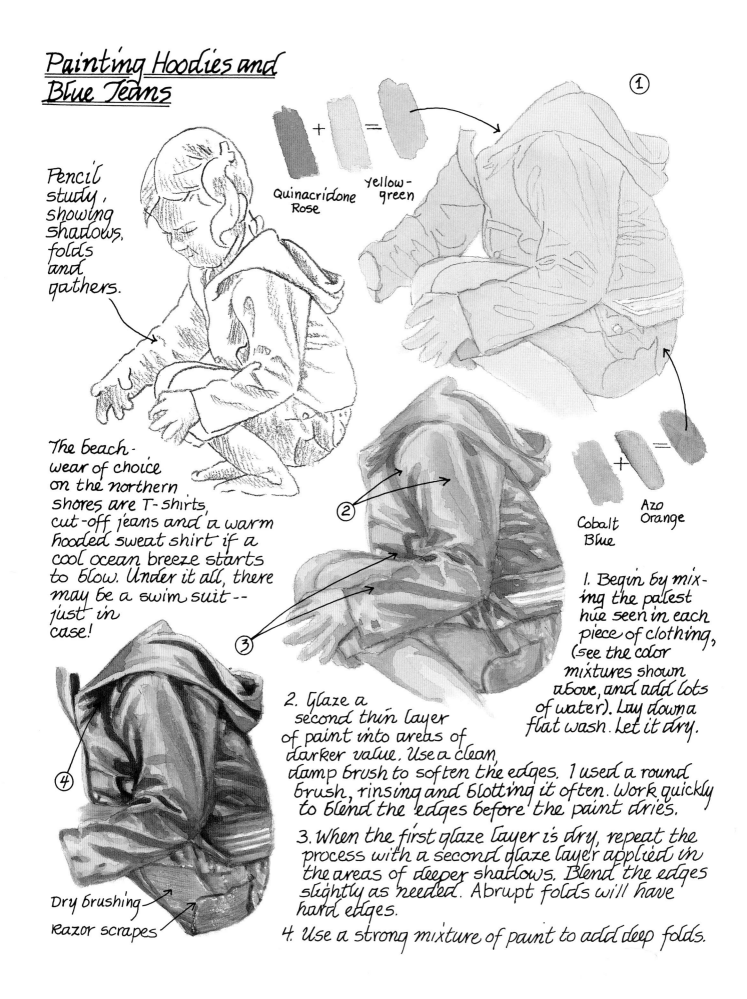

①

Pencil study, showing shadows, folds and gathers.

Quinacridone Rose + Yellow-green =

The beach-wear of choice on the northern shores are T-shirts, cut-off jeans and a warm hooded sweat shirt if a cool ocean breeze starts to blow. Under it all, there may be a swim suit -- just in case!

②

③

④

Cobalt Blue + Azo Orange =

1. Begin by mixing the palest hue seen in each piece of clothing, (see the color mixtures shown above, and add lots of water). Lay down a flat wash. Let it dry.

2. Glaze a second thin layer of paint into areas of darker value. Use a clean, damp brush to soften the edges. I used a round brush, rinsing and blotting it often. Work quickly to blend the edges before the paint dries.

3. When the first glaze layer is dry, repeat the process with a second glaze layer applied in the areas of deeper shadows. Blend the edges slightly as needed. Abrupt folds will have hard edges.

4. Use a strong mixture of paint to add deep folds.

Dry brushing

Razor scrapes

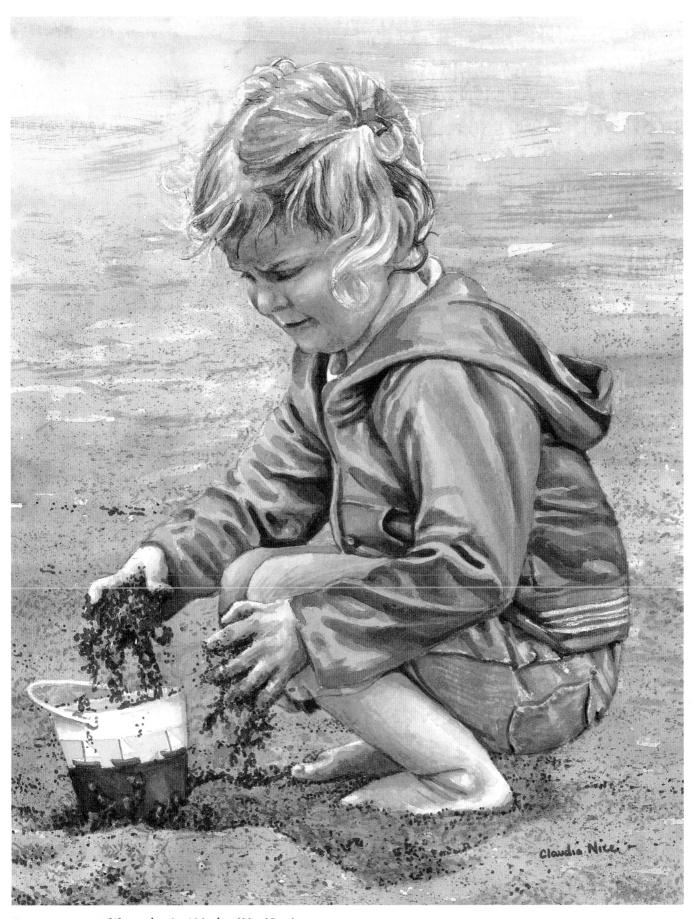

"SANDY HANDS" Watercolor, 8 x 10 inches (20 x 25cm)

Gray Pitt Pen (brush nib) stippling was used to texture the heavy clumps of sand.

Playing on the Rocks

The boy in this 8x10 inch watercolor painting was warned to stay off the cliff, but that doesn't stop him from climbing on the beach rocks.

Here are the steps I took in creating this painting:

1. Begin by painting the background. Keep the colors muted and resist adding too much detail. Apply the paint to a moist (not runny wet) surface and let the colors flow and mingle. I made several color mixtures for each area which varied slightly in hue. Let each area dry before painting the section beside it.

SKY: Ultramarine Blue + Phthalo Blue + water.

TREES: Blue-green + a little red-orange to mute the color + water.

BRUSH AREA: Sap Green + Yellow Ochre + water. Tap in a little of the tree color mixture and a little muted Burnt Sienna and let it mingle. (Use Sap Green to mute Burnt Sienna.)

CLIFFS: Burnt Sienna + Sepia, muted with touches of Sap Green. Thin with water.

DISTANT SAND PATCH: Cobalt Blue + Orange.

I used a 1/4 inch flat brush and a no. 4 round brush.

2. Use a .25 Rapidograph pen and water resistant brown ink (FW Acrylic Artist Ink) or a .005 Micron Pen (dark brown) and texture the rocks. I used contour lines for the smooth areas, and scribble lines and cross-hatching for rough places. Important: Work the ink lines over a damp surface so they fray out and soften. Shade the rocks with a mix of Burnt Sienna and Yellow Ochre watercolor.

Mask the branches.

3. Paint preliminary washes in the foreground.

CLIFF ROCKS: Phthalo Blue + Sap Green + red-orange + water. Add a touch of Payne's Gray for lower rocks.

GRASS, T-SHIRT: Permanent Green + Sap Green. Use Sepia for dark area below the grass.

SAND: Orange + Cobalt Blue + lots of water. Add more blue for the shadows on the pants.

SKIN, HAIR: See page 76. The hair is muted Burnt Sienna.

4. Remove the masking and paint the sticks with a Sepia wash. Using complementary color mixtures, add shadows and details. Refer to the painting on the opposite page as a visual guide.

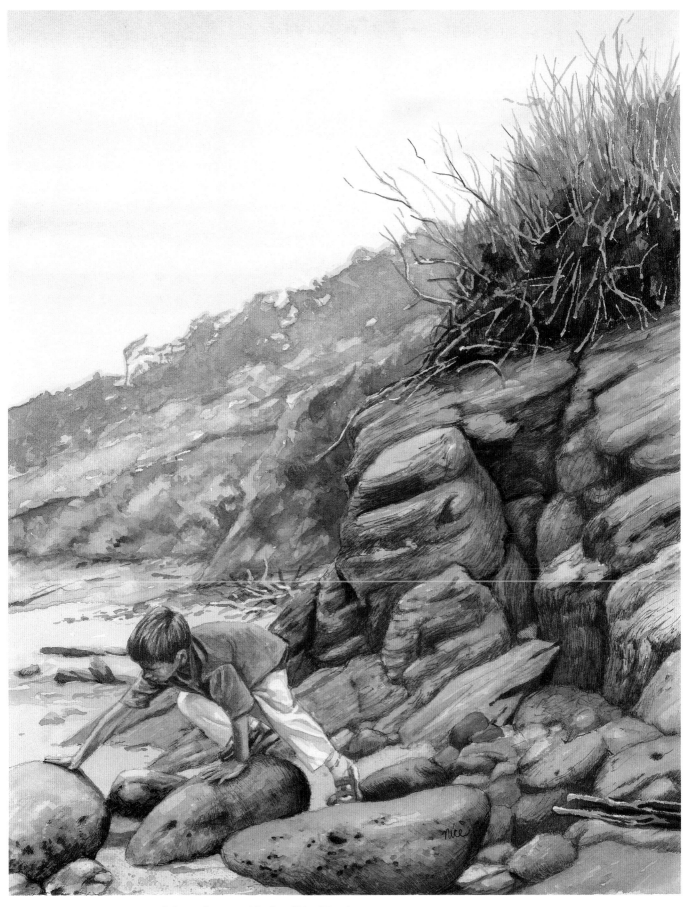

"PLAYING ON THE ROCKS" Watercolor, 8 x 10 inches (20 x 25cm)

<u>Wading</u> ~ A watercolor painting for you to experiment with.

1. Begin with a pencil outline.

2. Mask out some squiggly highlights in the foreground surf, shown in blue. I used a Masquepen for this.

3. Block in the lightest hue in each area using watercolor washes. Let each section dry before painting the one next to it. Refer to pages 18 and 76 for color mixtures for the water and skin tones.

The center of interest in this painting is the head and upper torso of the little girl. I chose a light, bright salmon color for her hooded sweat shirt, because red-orange complements the blue-green of the ocean. I mixed the salmon color using Scarlet Pyrrol (red-orange), muted with Phthalo Blue.

The navy blue in the shorts and shoulder stripe is a mixture of Ultramarine Blue and Payne's Gray.

4. Using glazing techniques, begin to develop the contours of the subjects. Add wrinkles and shadows to the clothing. Shade the hair and skin. Use a clean, damp brush to soften edges while they are still moist. Add horizontal ripples to the water and a bit of Yellow Ochre to the surf to represent churned-up sand. Use complementary color mixtures to create clean shadow hues.

5. Remove the masking and paint in the deepest shadows and final details. Refer to the painting on the opposite page as a visual guide. Highlights on the background wave and the jeans were scratched in.

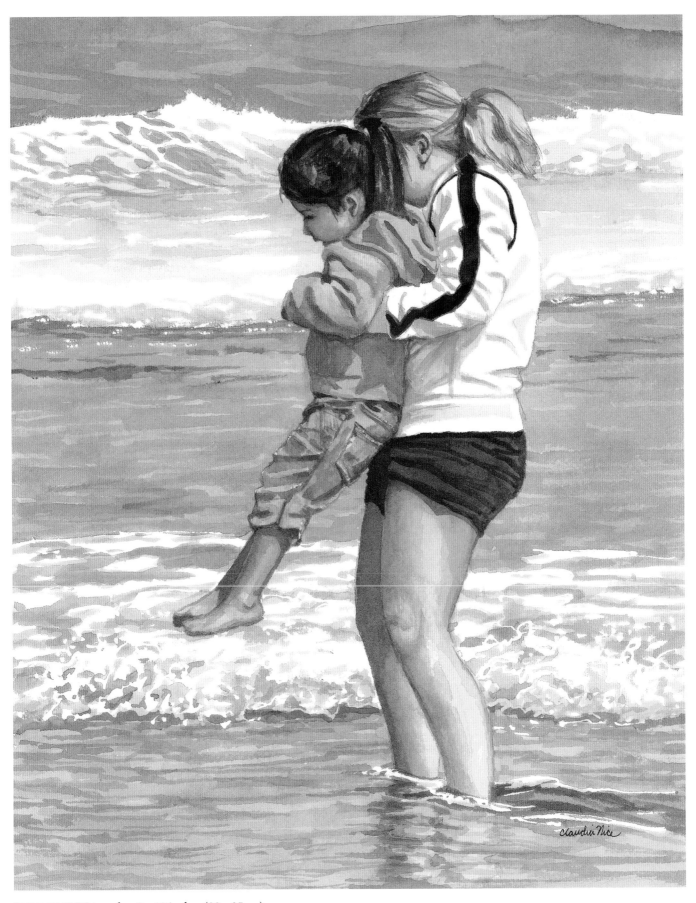

"WADING" Watercolor, 8 x 10 inches (20 x 25cm)

The bold texture in this painting of a boy and his dog was achieved by starting with a detailed pen and ink drawing, and then overlaying it with washes of watercolor. The striking red of the hat and sand bucket is counterbalanced with a bit of red in the sandals, a fine spatter of red in the sand, and a wash of reddish brown in the wolfhound's eye and coat.

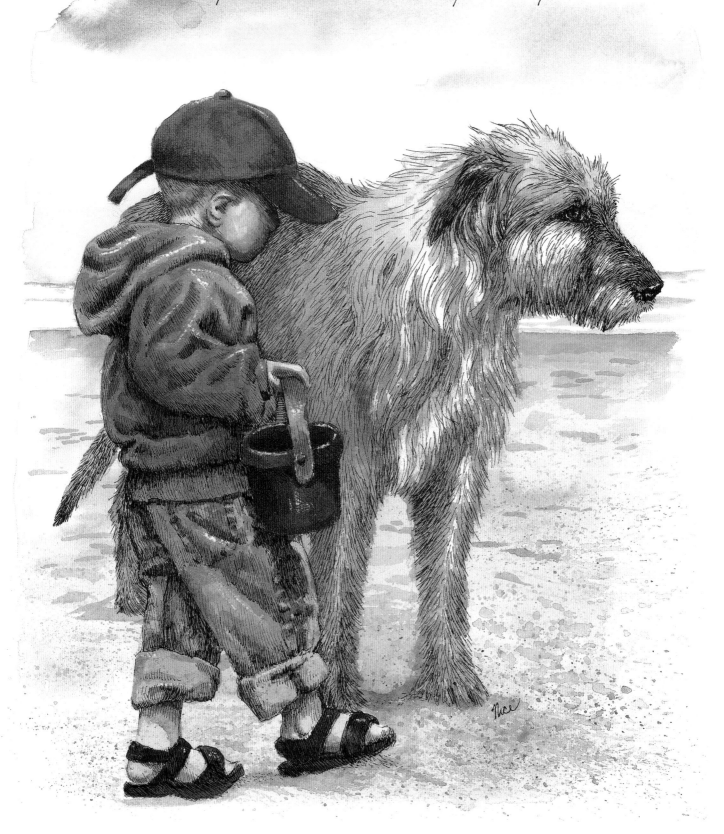

Dogs On the Beach

1 think there is something magical about the sandy shore that turns a dog into a frolicking puppy. Here's how I draw them.

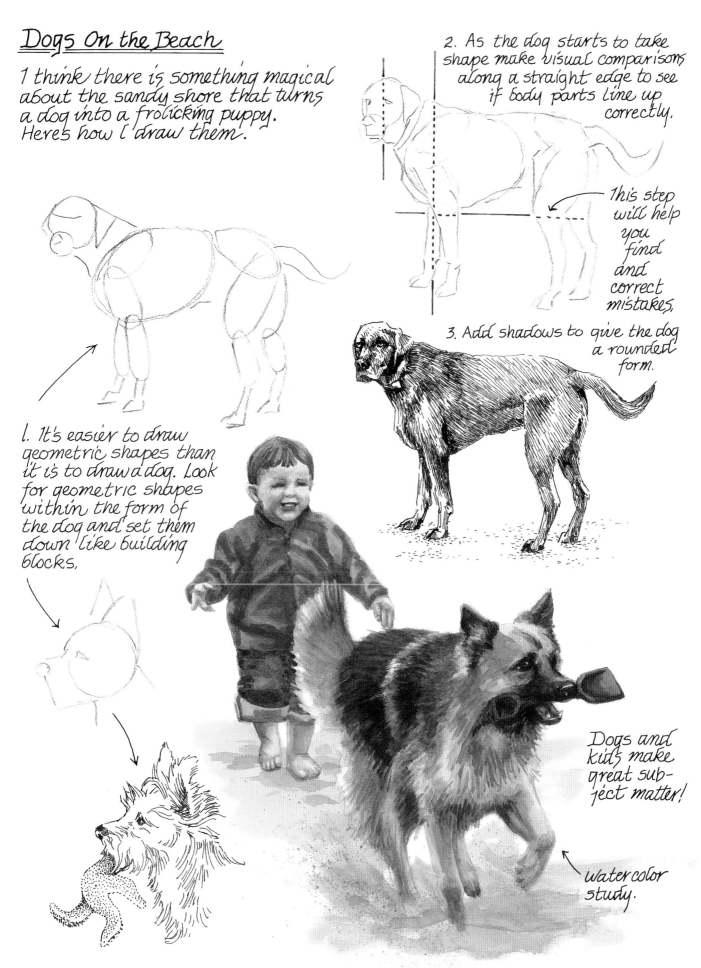

2. As the dog starts to take shape make visual comparisons along a straight edge to see if body parts line up correctly.

This step will help you find and correct mistakes.

3. Add shadows to give the dog a rounded form.

l. It's easier to draw geometric shapes than it is to draw a dog. Look for geometric shapes within the form of the dog and set them down like building blocks.

Dogs and kids make great sub-ject matter!

watercolor study.

The best subjects for a painting are those with which we are most familiar. Below is a photo of my white Shepherd, Merlin, running in the surf.

A dog in a three-quarters turned position will be foreshortened. The body parts closest to the viewer will appear larger than those set back a ways. In this case the head, chest and front legs are more prominent.

1. Study the photo. Make size and alignment comparisons. Look for geometric shapes and use them for building blocks.

Warm shadows—
New Gamboge,
plus Dioxazine
Purple

2. Complete the drawing. Make comparisons with your drawing and the source, using a straight edge to help you see clearly. Make any needed corrections. When the drawing appears accurate, you can pencil in the details like the eyes and teeth.

5. Add details. See finished painting on the next page.

3. Use watercolor washes to block in the shadows and colored areas. Leave the highlighted areas unpainted.

4. Use the glazing technique over dry surfaces to deepen shadows.

Sepia

Cool shadows—
Cobalt Blue plus
Azo Orange.

Masked area

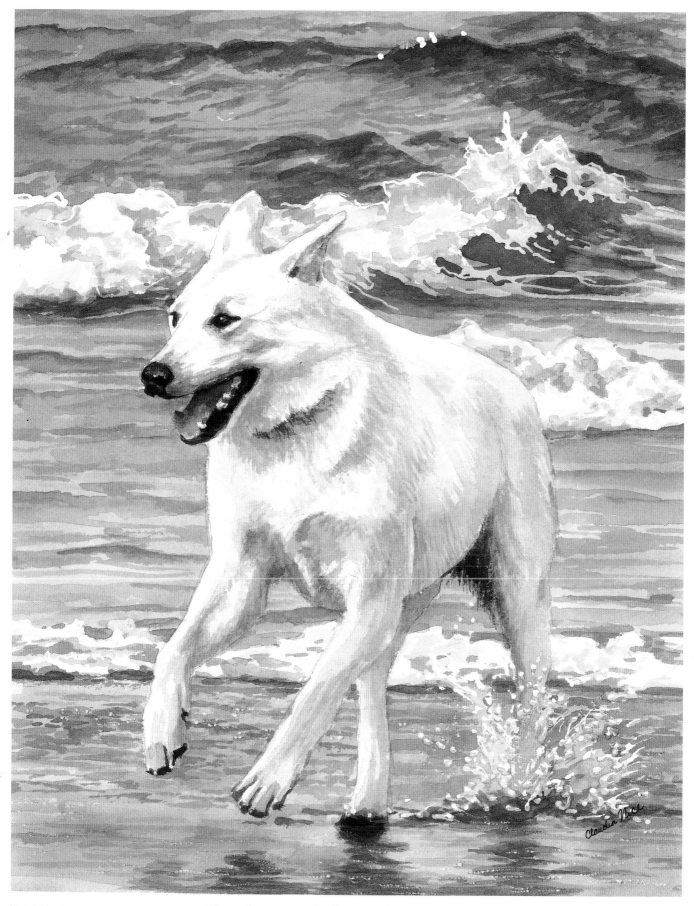

"WHITE SHEPHERD IN THE SURF" Watercolor, 8 x 10 inches (20 x 25cm)
A no. 4 round brush and the dry-brushing technique were used to add the final hair strokes to the dog's coat and the ripples in the waves.

Painting a Sand Castle

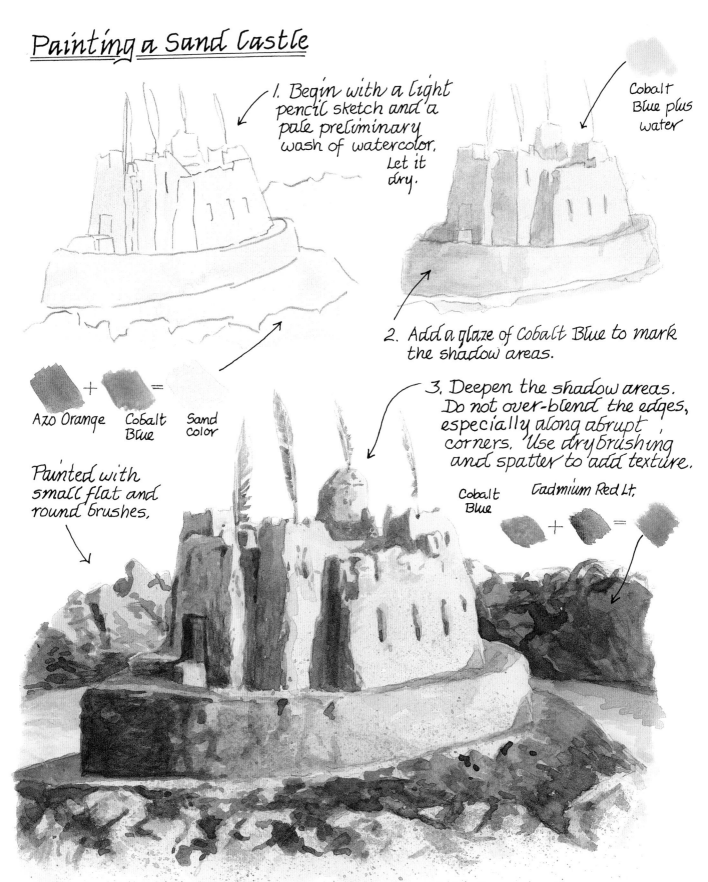

1. Begin with a light pencil sketch and a pale preliminary wash of watercolor. Let it dry.

Cobalt Blue plus water

2. Add a glaze of Cobalt Blue to mark the shadow areas.

Azo Orange + Cobalt Blue = Sand Color

3. Deepen the shadow areas. Do not over-blend the edges, especially along abrupt corners. Use dry brushing and spatter to add texture.

Cobalt Blue + Cadmium Red Lt. =

Painted with small flat and round brushes.

The acrylic painting on the opposite page, entitled SAND CASTLE BUILDER, was painted using similar color mixtures. Brush strokes were kept loose.

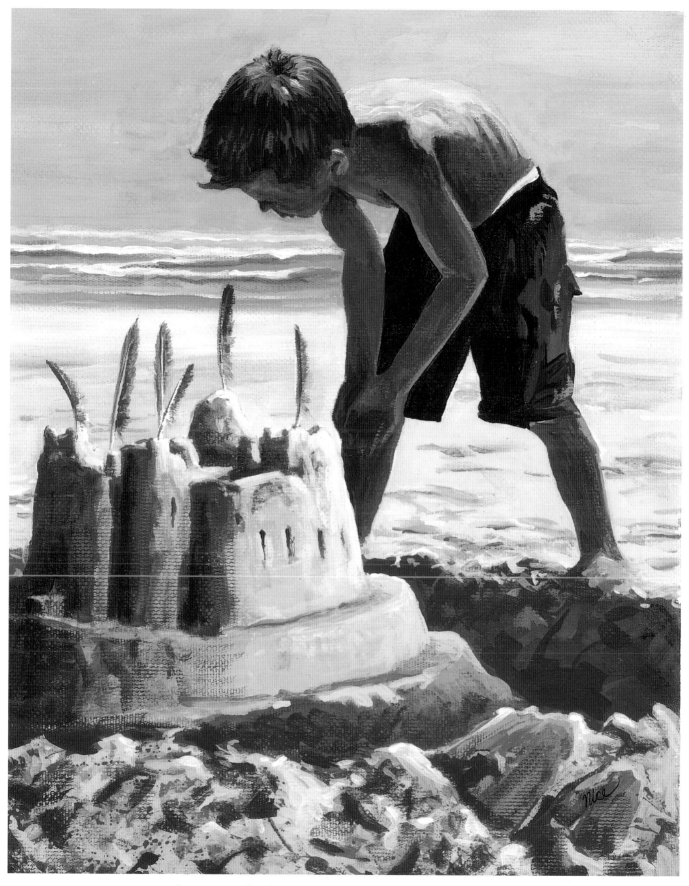

"SAND CASTLE BUILDER" Acrylics, 8 x 10 inches (20 x 25cm)

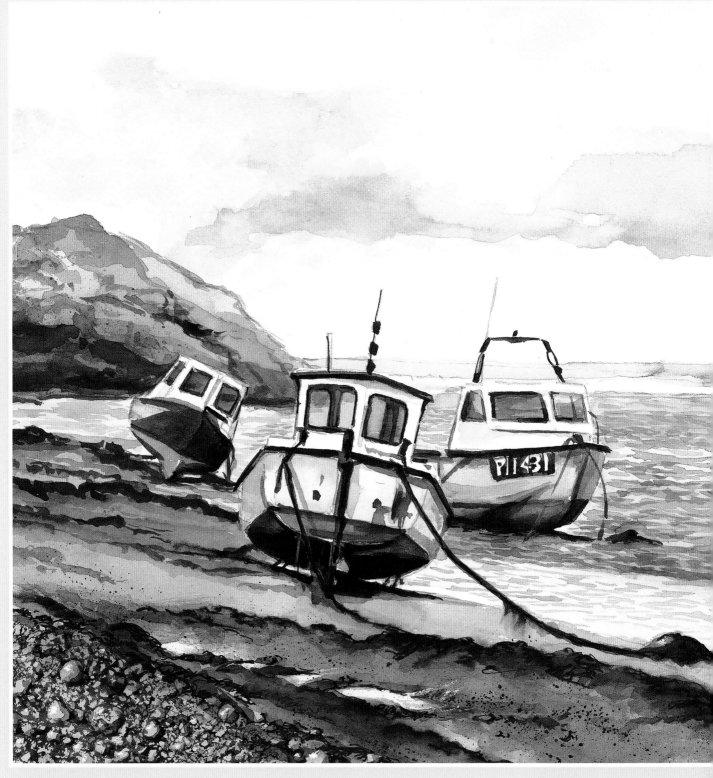

"THREE BOATS ON THE BEACH" Watercolor, 8½ x 11½ inches (21.5 x 28.5cm)

Harbors, Boats and Marinas 5

I REMEMBER HOW EXCITED I GOT AS A CHILD, when we launched our sturdy little wooden boat into the bay, and my sister, my parents and I climbed aboard. It spelled high adventure. All around us, bigger, fancier boats plowed across the swells, but our craft was strong and rode the waves like a dolphin. Sometimes we threw crab pots into the dark waters off shore and hauled aboard our limit of feisty Dungeness crabs. At other times, when the weather was mild and the bar was calm, we took our boat to sea. It was a little scary riding up and down the big ocean swells, but that was part of the thrill. The other part of the adventure was hooking and landing a salmon that was almost as big as my little kid self. They were huge and plentiful in those days.

Old wooden boats still hold a fascination for me. They must appeal to others, too, for they pop up time and again in photos and paintings. Not only are their shapes and colors interesting, but they remind us of the nostalgic past and countless waterborne adventures.

The painting of the three fishing boats on the facing page was done in England. The tide was out, leaving the vessels resting on their keels. I loved their primary colors, slightly faded by the sun, and the way the blue boat tilted towards the other two, as if straining to hear a whispered conversation. The earthy colors of the beach and the textures of the rocks, seaweed and water ripples provided a nice contrasting background to set the boats against. Parts of the composition were provided for me by the actual scene. In other areas of the painting I added, moved around or deleted items to provide a better balance of lines, shapes, colors, lights and darks. The emphasis of this chapter is to help you draw and paint simple boats and to learn how to turn a busy, complicated harbor scene into a well-composed painting.

Simple Boats

I find boats harder to draw than either buildings or people, because of all the curves and angles. As I sketch them, I rely heavily on comparisons made with the help of a straight edge, to enable me to see the subject correctly. Notice, the two angles I marked in ink in the photo. The bow angle matches that of my preliminary drawing. However, the angle line of the stern, laid across my drawing, reveals a mistake. My stern angle is too steep.

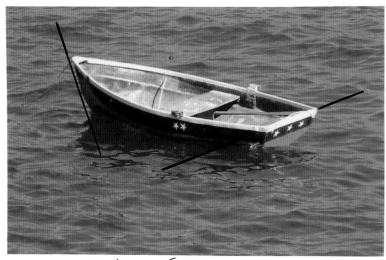

Reference Photograph

① Preliminary drawing.

Correction made.

② Pencil drawing with corrections made and details added.

③ First watercolor washes are laid down.

④ Additional watercolor washes give shadows, depth and details to the painting.

When water is undulating in ripples or small waves, the color and shape of cast reflections is distorted. Reflections are often broken up and mingled with bits of sky color, as seen in the reflection of this boat.

Drawn correctly

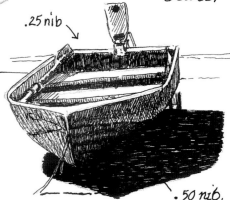

In this bow-first, foreshortened view of a boat, the length of the boat is suggested by the number of seats.

.25 nib

.50 nib.

Although we know that a boat is longer than it is wide, it should be drawn the way the camera sees it in a foreshortened view and not the way the mind perceives it.

Drawn incorrectly

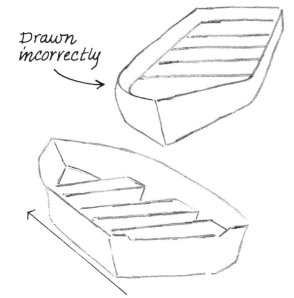

Watercolor with drybrush texture.

Note that the boat in this photo tilts upward as it rests on the bank. Marking this upward angle on your drawing surface is a good idea. It will help you keep the boat in perspective as you proceed.

You need not draw everything that appears in a photo. I chose to remove the motor which tended to date the scene.

Once the boat is drawn, choosing a style and medium with which to finish it will the 'affect the mood of the art piece as well as its overall appearance. This old Alaskan fishing boat looks bleak and desolate as a pen and ink drawing.
The texture and bold contrasts are the emphasis of the work. .25 and .50 Rapidograph pens were used.

NICE

Adding watercolor washes over the ink work makes the scene appear less stark. It now takes on a fun, illustrative look.

"OLD ALASKA FISHING BOAT" Watercolor, 8 x 10 inches (20 x 25cm)

In this watercolor version of the old fishing boat, I added a bright background and put sunlight in the foreground grasses, giving the painting a cheery appearance. Dry-brushing was used to give the boat an aged look.

Painting a Boat Under Sail

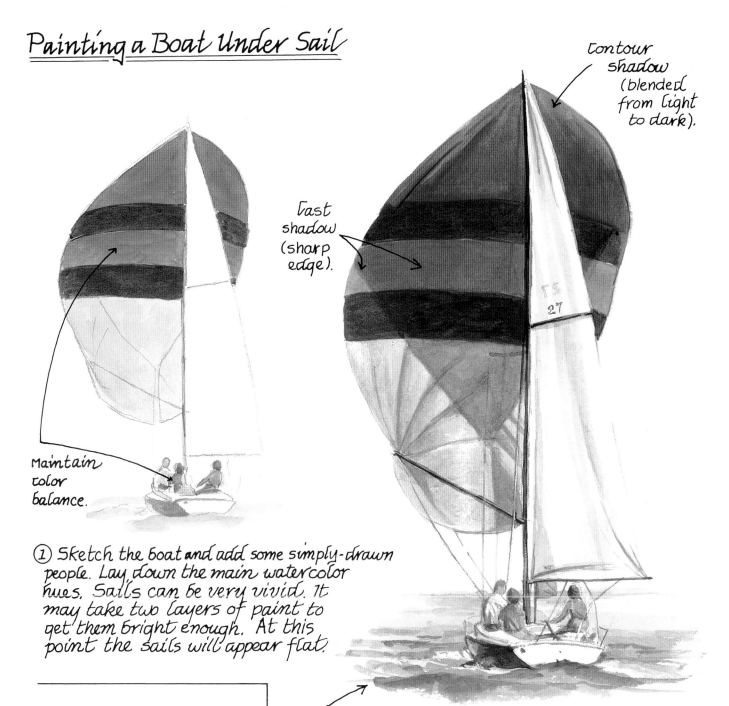

Contour shadow (blended from light to dark).

Cast shadow (sharp edge).

Maintain color balance.

① Sketch the boat and add some simply-drawn people. Lay down the main watercolor hues. Sails can be very vivid. It may take two layers of paint to get them bright enough. At this point the sails will appear flat.

Color Balance

If your sail boat has bright, colorful sails, repeat the vivid hues in other portions of your painting to maintain a balance of color. Water reflections, clouds, and the clothing on the sailors can all be used as places to repeat an eye catching hue.

② Use complementary color mixtures to create shadow hues. Shade the boat, sails, people and waves to give them contoured shapes. Remember to include both contour shadows and cast shadows. Keep details on the boat and human figures to a minimum.

③ Add the lines and rigging to the boat. It's easy to get the lines darker and wider than intended. White gouache is helpful in reducing "fat" rigging lines.

Creating a Good Composition

Once you have found the scene you want to paint, take a few minutes to study the possibilities. Which view would make the best composition? Making thumbnail sketches or taking some digital reference photos may help you decide. Here is a list of things to consider when planning a composition:

1. Choose a focal point for your composition and zero in on it. All the other elements in the scene should support this center of interest, helping to either define it or contribute to the overall balance of the composition. Watch out for elements that strongly detract or compete with the focal point.

2. Look for a variety of interesting shapes and lines. Use an assortment of horizontal, vertical, diagonal and rounded, centered shapes in your composition. Designs that have numerous forms and lines all moving in the same direction will pull the eye of the viewer right out of the picture.

3. Make sure your scene has a good value contrast (strong highlights and shadows). If the main subject or focal point is contrasted against a light or dark background, it will emphasize its importance.

4. Create color balance. Plan out a color scheme and limit your palette to just a few dominant hues, which harmonize or complement each other. Make sure you repeat bright, eye-catching colors or variants of those hues in several other locations.

5. Textures can add interest to a composition. Does your scene have any areas where the texture can be emphasized, such as grass, sand, old wood, shingles or choppy waves?

6. Remove the junk! Delete any items that don't contribute to the balance, mood or message of the composition.

7. Use your artistic license to make improvements to the composition. Add, change or relocate shapes, colors, textures, etc., to make up for weak areas in the original scene. However, when introducing new items into the picture, make sure that the lighting and perspective of the new addition is compatible with the rest of the composition.

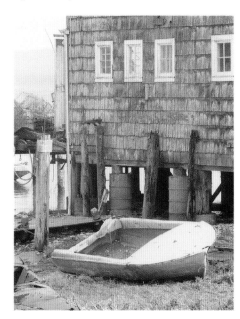

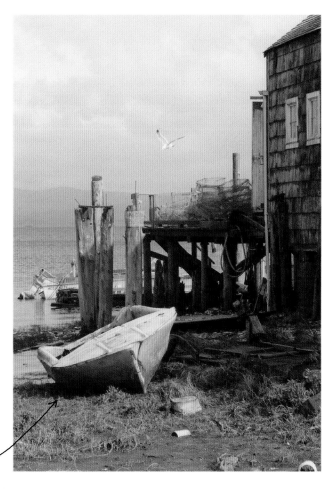

Study these two photos. Considering the list above, can you see why I chose the one on the right as the basis of my painting and why I made certain changes in the scene? Note how the deep shadows pop the center of interest (the boat) into focus.

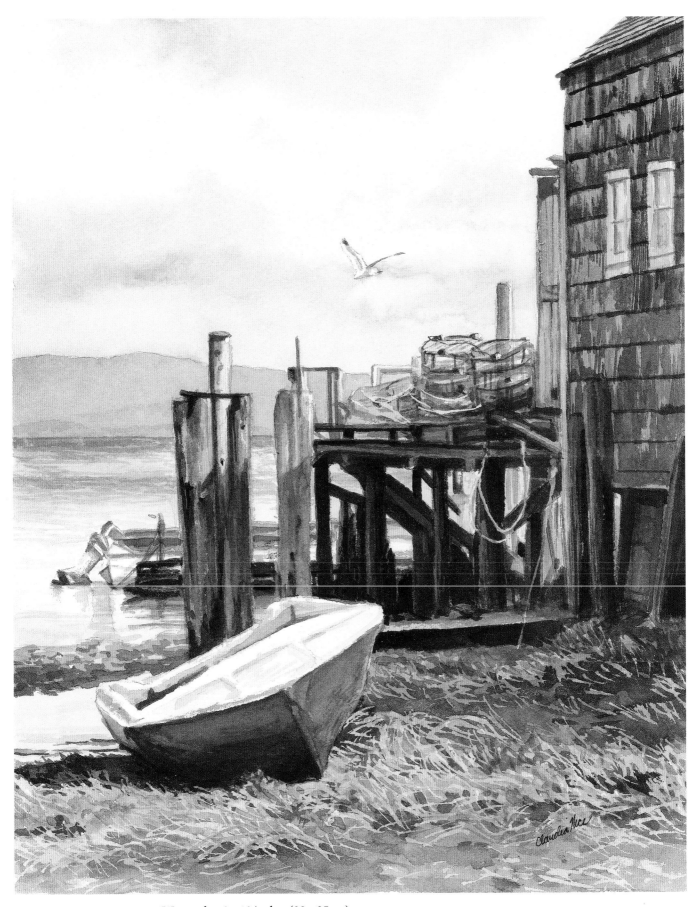

"RED BOAT AND WHARF" Watercolor, 8 x 10 inches (20 x 25cm)

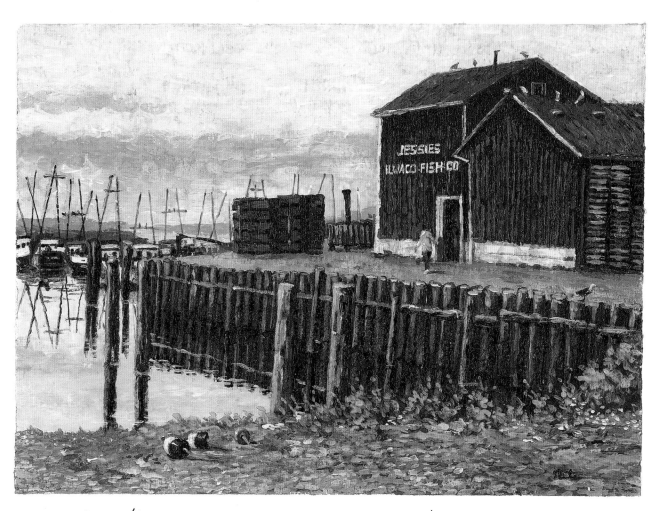

Busy marinas like the one in the photo below, are full of interesting shapes, colors and reflections. However, to paint them in their entirety would be overwhelming for both the artist and the viewer. Tame the scene by focusing on one main subject. I chose the bright red cannery building as my center of interest and moved in closer to it. In doing so, many of the competing shapes were eliminated.

Too many centers of interest!

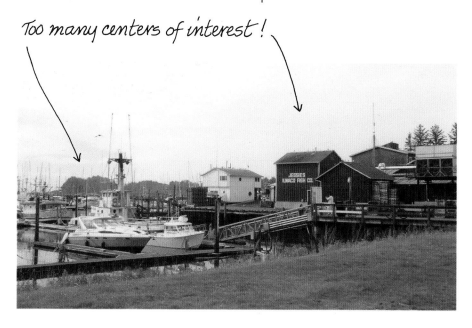

The painting above is an acrylic and the one on the opposite page was created with water-colors. Although I used the same paint colors in both, the water-color scene has the light look of an over-cast morning, while the heavier quality of the acrylic paint suggests an incoming squall.

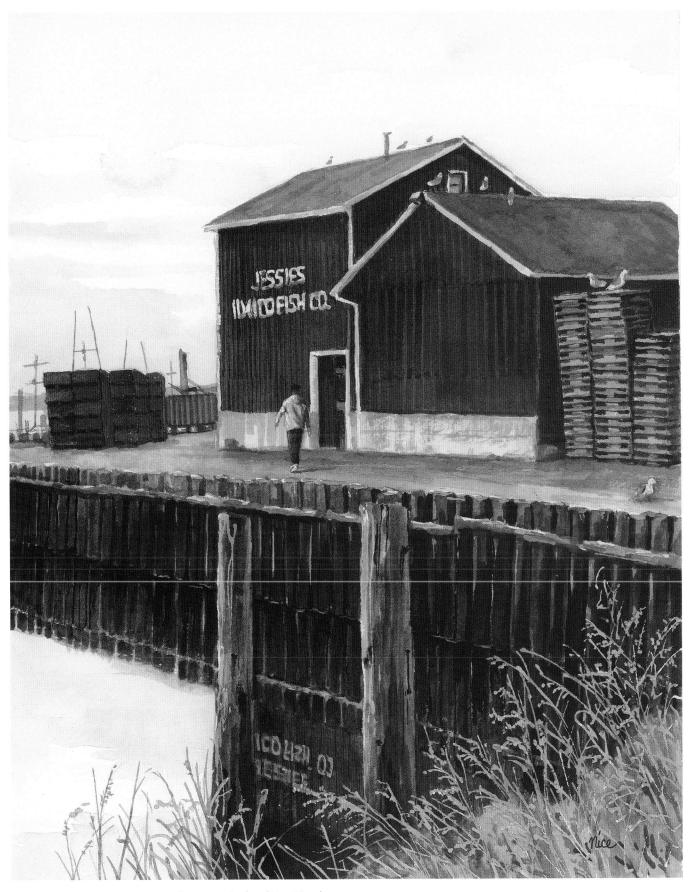

"RED FISH CANNERY" Watercolor, 8 x 10 inches (20 x 25cm)

Painting Calm Water Reflections

The protected water inside a harbor or marina may appear calm, with a glassy, mirror-like surface, but it is actually rising and falling in gentle swells with the flow of the tide and currents. The result is distorted reflections which make wonderful, wiggly designs across the water's surface.

Here are the steps I took in painting the sunset harbor scene on the opposite page.

① Lay down the preliminary washes for the water. It should reflect the colors used to paint the sky. Let it dry.

Cobalt Blue plus Phthalo Blue, muted with a touch of orange.

CB PB O =

Important note!

Leave any areas that will be painted lighter or brighter than the color of the water, unpainted. In this scene, that would be the electric light reflections.

② Paint in the bright reflective areas. They will appear elongated and widened into gentle ripples. Strips of sky color may appear across the reflections.

③ Add some gentle swells to the water by painting in some slightly darker streaks. Blend and soften the edges.

④ Paint in the rest of reflections, working from the lightest tones to the darkest. Refer to the finished painting (opposite page).

Keep in mind –

When the light sources, in this painting the sunset and electric lights, come from behind the subjects, the reflections will be dark like shadows. Whites become grays and deeper values become almost black. **Only the reflections of the lights and nearby objects are bright.**

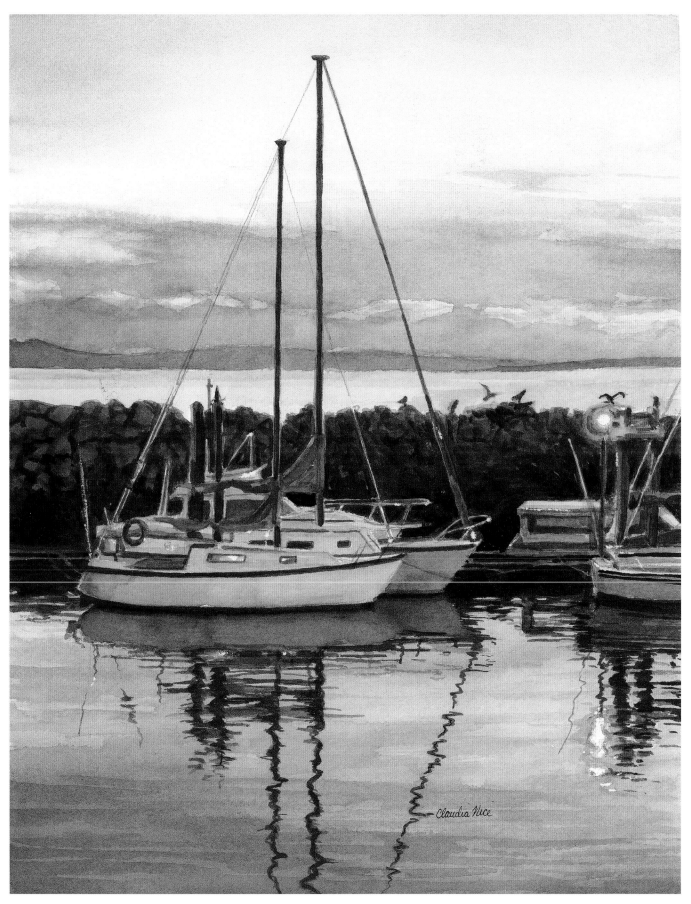

"SAILBOATS AT EVENTIDE" Watercolor, 8 x 10 inches (20 x 25cm)

Painting a Bright-Hued Net Float

Cadmium Yellow or Hansa Yellow Deep

Cadmium Red Lt.

Cadmium Red Lt. plus Maroon Perylene or Permanent Green Lt.

Cobalt Blue plus Phthalo Blue

Drybrush mix
Gamboge with a touch of Cadmium Orange, added. Mute the mix with Ultramarine Blue / Diox. Purple.

①

②

③

Drybrushing

Phthalo Blue and Green plus a touch of red-orange

④

1. Use a round brush or very small flat brush to apply the yellow watercolor paint to a damp surface. Cover the float half way across. Let the moisture settle into the paper and add a stripe of red. Let the colors flow together and mingle along the edge. Use a clean, damp brush to control runs. Repeat the process, adding the dark red mix. If colors dry too pale, add a second layer of paint. Acrylic paint may be substituted, but colors must be blended together with a brush.

2. Add a stripe of blue.

3. Darken the right side of the blue stripe by working in more of the blue mix with orange added. Use a small flat brush to drybrush a little of the brown-yellow mix vertically across the float. Basecoat the rope.

4. Add the finishing details. Texture the rope with a small round detail brush and a darker blue-green mixture. Add some dark red spots to represent holes. Use a razor blade to scrape a vertical row of highlight marks where the red and yellow meet.

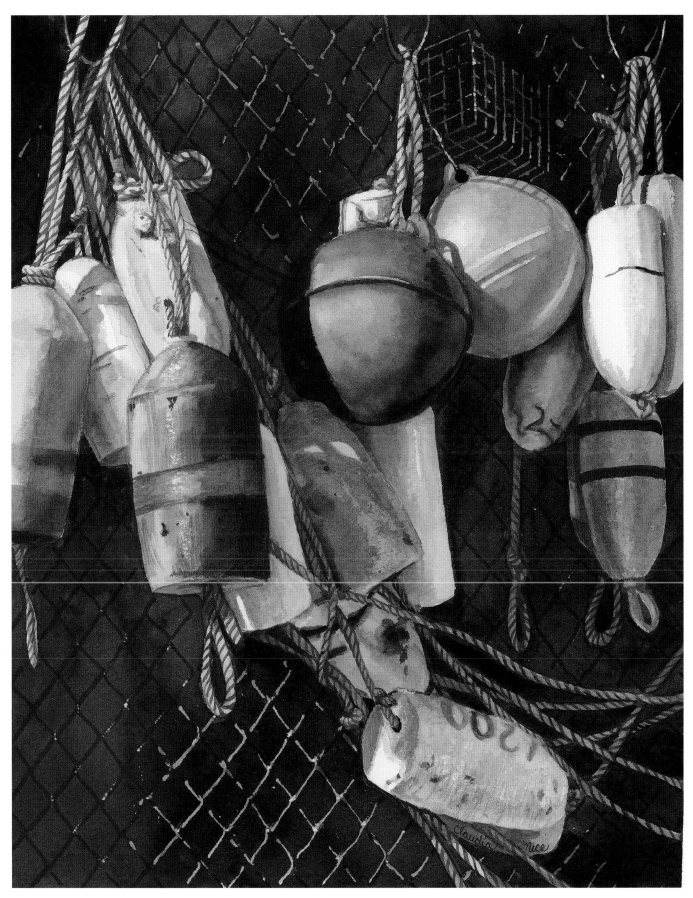

"A COLLECTION OF NET FLOATS" Watercolor, 8 x 10 inches (20 x 25cm)
Masking fluid was used to preserve the light areas of the chain link fence.

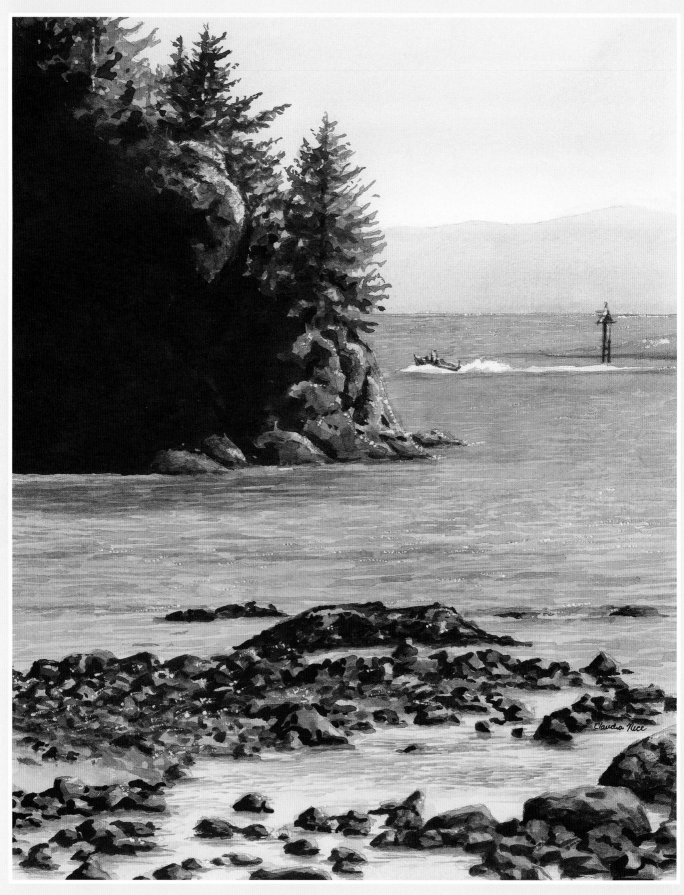

"UP RIVER, LOW TIDE" Watercolor, 8 x 10 inches (20 x 25cm)

6

Stillwater Marshes and Deepwater Bays

YOU DON'T HAVE TO BE STANDING NEAR THE SEA to get the feel of the ocean in your waterscapes. Inland a ways, where the tides bring the tang of salt water into the rivers, bays and estuary marshes, you can find lots of interesting subjects to paint. These scenes are related closely to the seascape, but exhibit a uniqueness all their own. When the tide goes out, gravel beaches are revealed and mudflats are uncovered. These areas are rich in color and texture. As you can see in the river painting on the facing page, seaweed and algae can be as bright as the evergreen trees clinging to the cliffs; and the rocky shores, strewn with bits of shell and driftwood, make a wonderful foreground. When the tide comes in, the bays take on a lake-like appearance, and the marshes show little trace of their salty heritage. So if you just want to learn how to paint your favorite lake or body of still water, even as far inland as the Great Plains, this chapter will be helpful.

Mood is an important element within a composition and I will show you how to use color and design to enhance the "happiness" and serenity of a waterscape, or how to bring your viewers the feeling of awesome respect when viewing a turbulent bay scene.

Waterfowl can be found in abundance in the estuaries. In addition to the typical gulls, you can see a variety of ducks, cranes and herons. The Great Blue Heron, standing tall and statuesque at the edge of the bay or wading in a pond, presents a vertical center of interest that is hard to resist. The ripple patterns cast across quiet waters by a pair of swimming ducks is equally enticing. Ocean mammals also frolic in these briny waterways. How about choosing a seal or sea lion as the main attraction in your composition? They like to frolic in the bays, and sea lions swim up-river many a mile to hunt and sun bathe on house docks. Within the next few pages you will find examples of these various animals, along with demonstrations on how to draw and paint them.

Painting Bay Shorelines

It's common for bays to have rocky shores and pebble beaches. At low tide the mud flats appear -- stretching out in the receding water with far-reaching fingers the color of a faded army blanket.

Watercolor wash over pen and ink.

Side view of a mud flat drawn in perspective.
The edges are flat and horizontal where they enter the water.

The rounded indentations in this mud bank make it look like you are viewing it from the side and from overhead at the same time. The perspective is wrong.

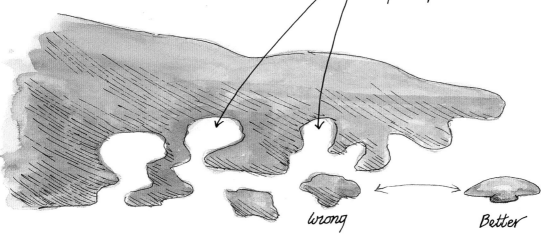

wrong

Better

Willapa Bay Project

Although Willapa Bay is located on the Southern coast of Washington State, its rocky shore line and marsh grass inlets look just like numerous other bay and lake shores, especially at high tide. Feel free to use this as a practice piece, adding your own flourishes as you work along.

1. I began this watercolor painting by using a Masque pen to mask out the highlighted clumps of foliage in the trees and bushes, the strips of light-colored pebbles and the dry grasses (shown in blue-green).

2. Using a flat brush, I laid a mixture of Cobalt Blue / Phthalo Blue, muted with a touch of Cadmium Orange, over the sky and water. Lay it down quickly and smoothly, brushing across horizontally.

Terra
Rosa

Cadmium
Yellow

Olive
Green

Sap
Green

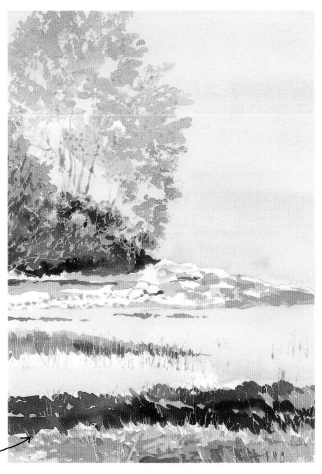

3. Using numerous mixtures of the four colors shown above, I began to lay down the preliminary washes in the rest of the painting. Sometimes I laid a wash next to another moist color and allowed the hues to charge together and mingle. Dip the brush freely from one color to another and keep your strokes free and loose. I used a round brush for the tree foliage, and a small flat brush in the mud flat area.

111

Only a portion of the branches are seen through the leaves.

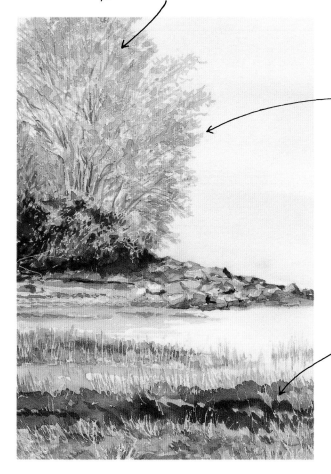

4. I filled in the remaining unpainted areas, using the palest wash intended for each spot. Some of the rock areas were so light, they almost dried white. The paint was allowed to dry completely.

5. Using the same mixture or slightly stronger ones, I began to glaze over each area adding midtones. I made sure that wherever I worked, I left some of the original base coat color to show through. For the tree leaves, I used a number four round brush and tapped in little clumps. I wanted lots of sky to show through so it would look like delicate spring leaves just opening.

Long, light green strokes represented new spring grass mingled among the brown ones of last winter.

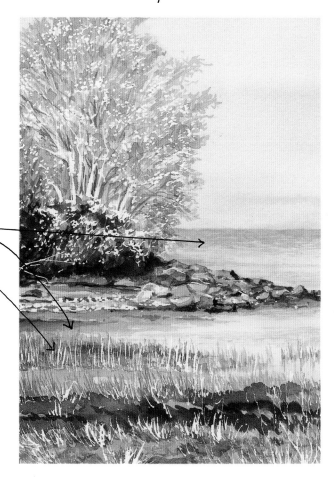

6. Using a darker shade of the sky and water mix, I added horizontal ripple lines to the water. A small, round detail brush or liner is good for making these narrow lines. I also added strips of reflective color in the still, shallow water areas.

7. The masking was removed, revealing the highlight areas.

8. While some of the highlights in the bank and on the trunks of the trees were left white, other areas were glazed with light or bright washes. The Cadmium Yellow/Sap Green mix used in the tree leaves and Cadmium Yellow used in the shrubs were repeated in the marsh grasses. Details and dark shadows were added. See the finished painting on the opposite page.

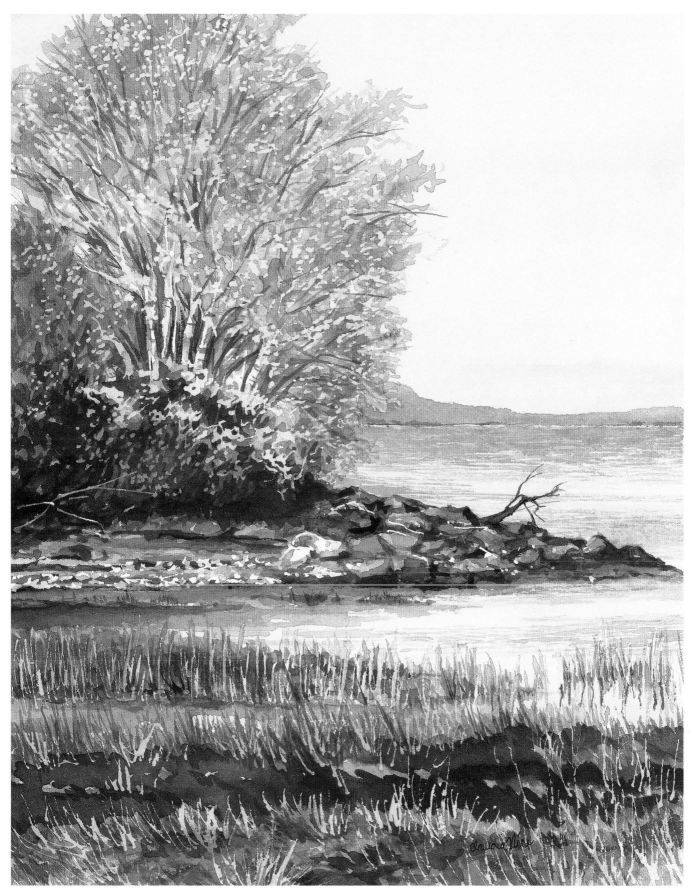

"WILLAPA BAY" Watercolor, 8 x 10 inches (20 x 25cm)

Painting Choppy Water

The mood of the deep water bays can change quickly from near calm (opposite page) to rough.

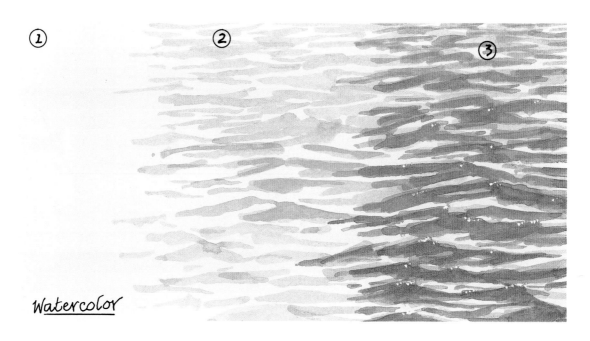

Watercolor

Here are the steps I use to paint choppy waves.

1. Base coat the area in the lightest wave color to be used. This will be sky reflection.
2. Using a slightly darker version of the same color mix, create elongated "hills." A round brush works well for this. This represents the back side or shadow side of each wave. The steeper the hill, the rougher the water will be.
3. Use a third, darkest hue to deepen some of the wave shadows. Paint or scratch in a few sun glisten spots on the crest of the waves.

Acrylic

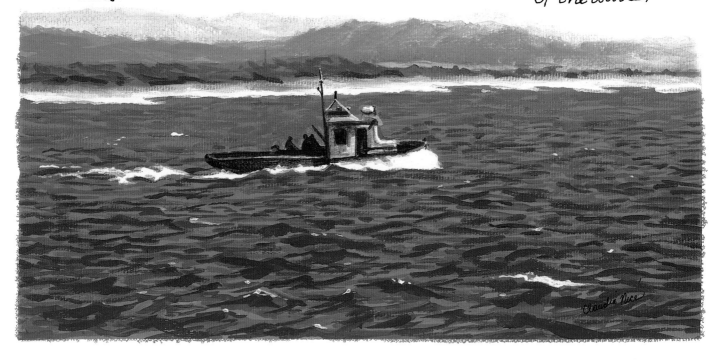

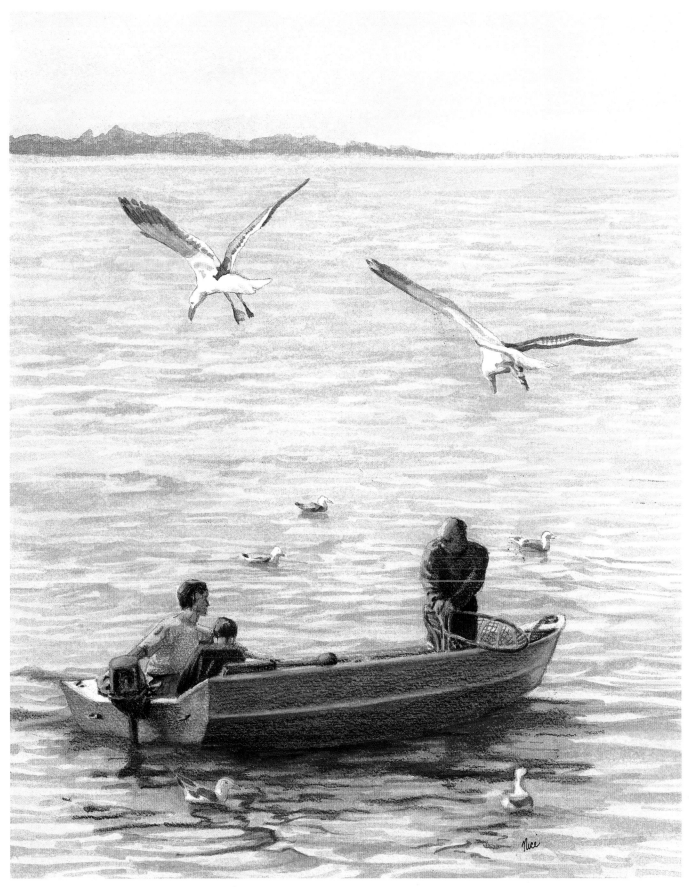

"PREPARING THE CRAB POTS" Watercolor, overlaid with colored pencil detailing in the foreground, 8 x 10 inches (20 x 25cm)

Harbor Seals

A group of harbor seals makes a nice center of interest in a bay shore or harbor scene.

Seals have blubbery, well rounded bodies. Use lots of circles, ovals and ellipses when blocking in their basic forms.

Large, dark eyes.

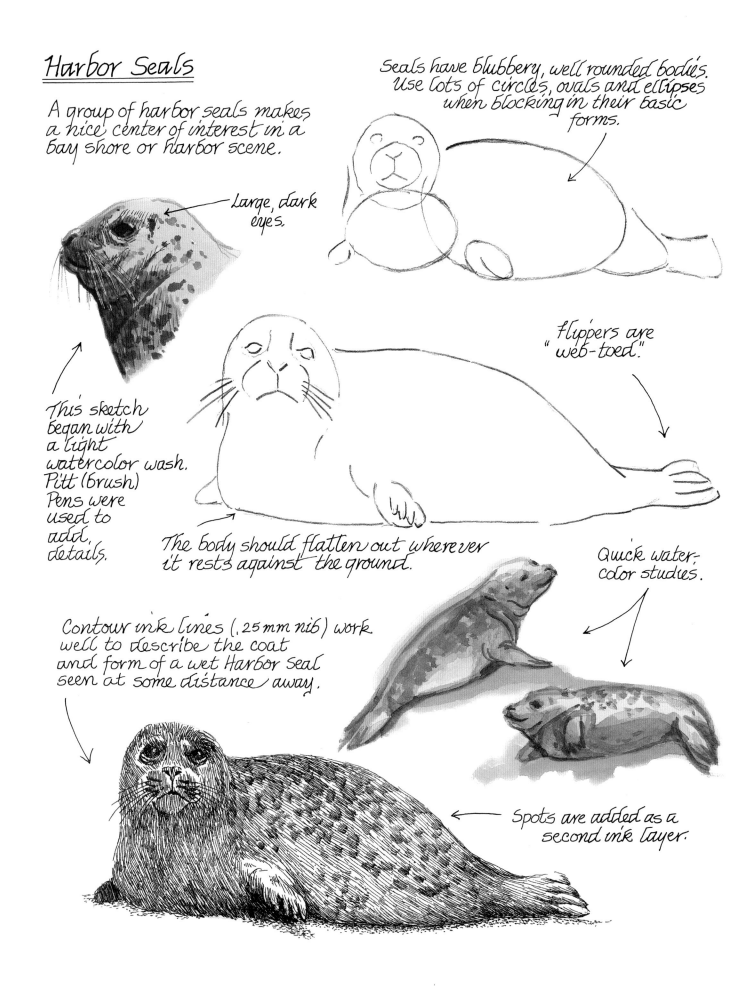

This sketch began with a light watercolor wash. Pitt (brush) Pens were used to add details.

Flippers are "web-toed."

The body should flatten out wherever it rests against the ground.

Quick water-color studies.

Contour ink lines (.25 mm nib) work well to describe the coat and form of a wet Harbor Seal seen at some distance away.

Spots are added as a second ink layer.

Sea Lions

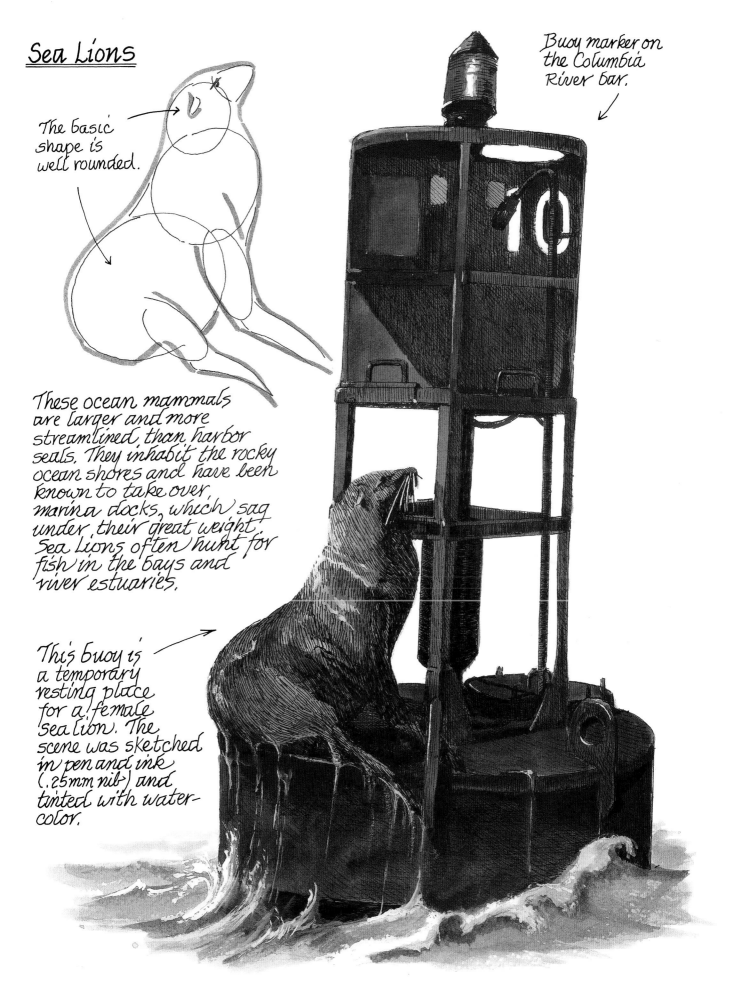

The basic shape is well rounded.

Buoy marker on the Columbia River Bar.

These ocean mammals are larger and more streamlined than harbor seals. They inhabit the rocky ocean shores and have been known to take over marina docks, which sag under their great weight. Sea Lions often hunt for fish in the bays and river estuaries.

This buoy is a temporary resting place for a female sea lion. The scene was sketched in pen and ink (.25mm nib) and tinted with watercolor.

Painting the Moods of the Bar

In case you aren't familiar with the term, a bar is a deep water channel that leads from the mouth of a river or bay out into the ocean. It is usually rimmed by rock jetties. The tides and weather conditions can change a calm bar into a raging fury of turbulent waves in mere minutes.

The pencil sketch on the right depicts a fairly peaceful bar. The shapes and shadows are adequate to describe the scene. However, the "mood" of the drawing is vague. In the watercolor version below, the warm earthy tones of the rocks, the cloudless blue sky and the bright blue-green of the sea, make it clear that the sun is shining. The mood is cheerful and a bit nostalgic.

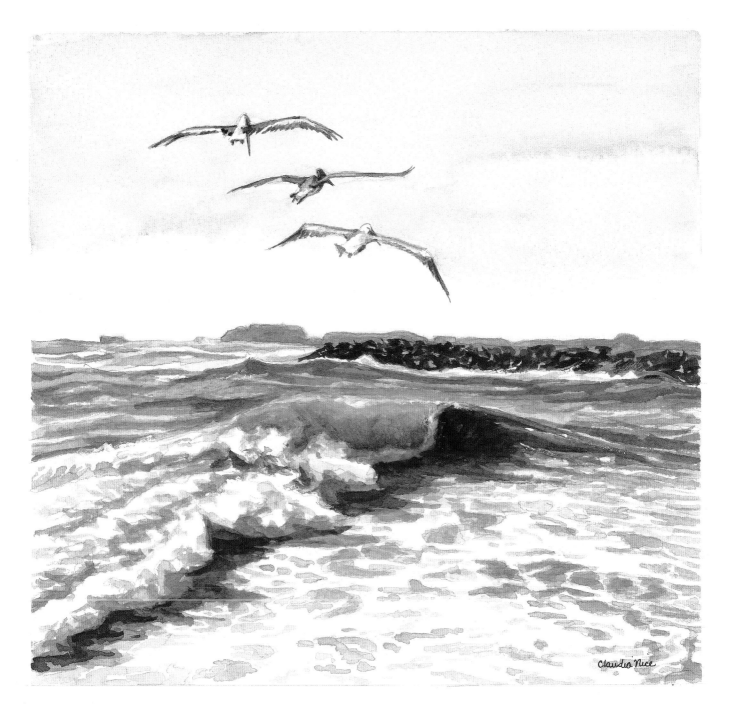

THREE PELICANS CROSSING THE BAR (watercolor)

The sun is also shining in this bar seascape, as indicated by the strong light and shadow contrasts, and the warm over tones on the water. However, the predominant blue-grays in the scene lend it a somber feel. The waves slamming together at opposing angles suggests power and turmoil. The mood is one of respectful excitement.

Estuaries

At high tide, estuaries resemble lakes, edged with mud banks and salt marsh grasses. A variety of water fowl call these tidal inlets home.

Mallard ducks →

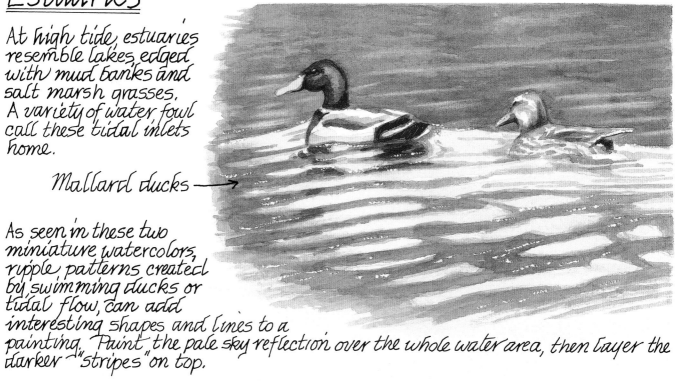

As seen in these two miniature watercolors, ripple patterns created by swimming ducks or tidal flow, can add interesting shapes and lines to a painting. Paint the pale sky reflection over the whole water area, then layer the darker "stripes" on top.

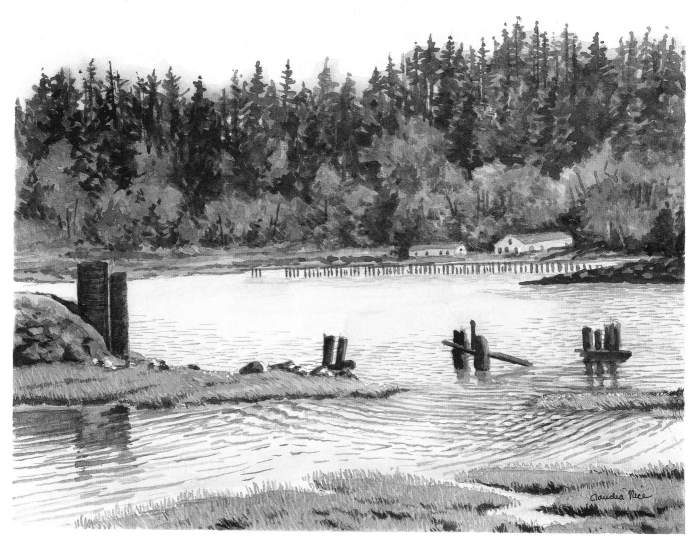

Claudia Nice

Duck Studies

The ducks on this page are Mallards. They're one of the most common water fowl in the Northern Hemisphere and can be found wherever there are wetlands, including estuaries.

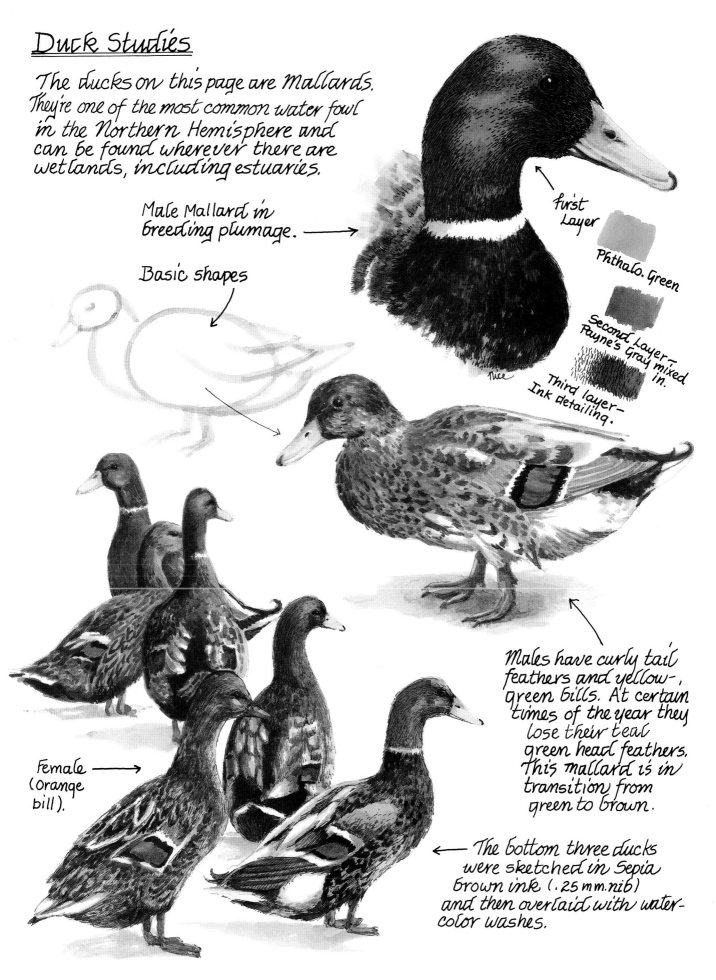

Male Mallard in breeding plumage.

Basic shapes

first Layer

Phthalo. Green

Second Layer— Payne's Gray mixed in.

Third layer— Ink detailing.

Males have curly tail feathers and yellow-green bills. At certain times of the year they lose their teal green head feathers. This mallard is in transition from green to brown.

Female (orange bill).

The bottom three ducks were sketched in Sepia brown ink (.25 mm. nib) and then overlaid with water-color washes.

Painting a Great Blue Heron in Watercolor

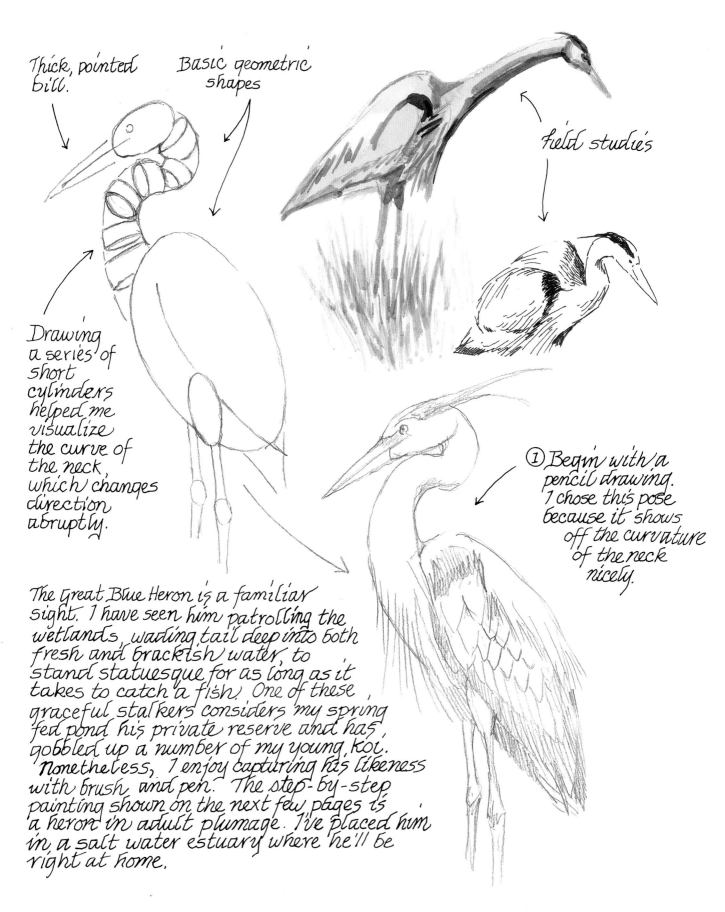

Thick, pointed bill.

Basic geometric shapes

field studies

Drawing a series of short cylinders helped me visualize the curve of the neck, which changes direction abruptly.

① Begin with a pencil drawing. I chose this pose because it shows off the curvature of the neck nicely.

The Great Blue Heron is a familiar sight. I have seen him patrolling the wetlands, wading tail deep into both fresh and brackish water, to stand statuesque for as long as it takes to catch a fish. One of these graceful stalkers considers my spring fed pond his private reserve and has gobbled up a number of my young koi. Nonetheless, I enjoy capturing his likeness with brush and pen. The step-by-step painting shown on the next few pages is a heron in adult plumage. I've placed him in a salt water estuary where he'll be right at home.

② Mask out the light grass areas and long white feathers as shown in blue.

Gamboge plus Dioxazine Purple

Payne's Gray plus Cobalt Blue.

③ Use a watered down version of the color mixtures shown above to block in the body of the Heron. Use Gamboge for the yellow areas and Burnt Sienna on the upper leg.

The grass is Permanent Green Lt. plus a touch of Azo Yellow. Keep the paint thin.

Add red to make dark shadow color seen between grass blades.

The water is mixtures of Burnt Sienna, Sepia and Sap Green. Brush on the browns horizontally.

④ Using slightly darker mixes, glaze on shadows and details as shown above. A no. 4 round brush or small flat works well.

⑤ Use a larger flat brush to block in the mud bank and water and a no. 4 liner to stroke in the grass blades.

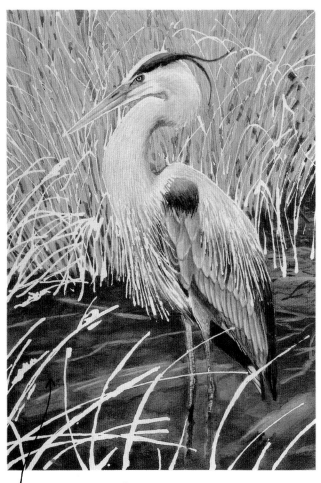

⑥ Mix Sepia with either Sap Green or Permanent Green Lt. to create a dark olive brown. Brush it horizontally across the water area and let it dry completely.

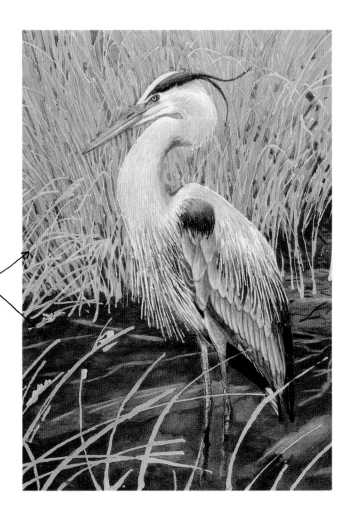

Using a small, flat bristle brush, dampen, work and blot up log and branch shapes in the water area of the painting. Work slowly and gently, lifting up paint and not paper. Let dry, and re-tint the lifted areas as needed. Add some dark branch shapes on the bank. Let dry.

⑦ Use masking tape, rolled around your finger sticky side out, to rub off the masking fluid. Some of the grass and feather shapes will be too wide. Trim them by working some of the background colors along their edges. Add dark leg reflections.

⑧ Paint in the white grass shapes using a very pale Permanent Green Lt. in the background and a darker, brighter green in the foreground. Pick up the color of the bill in the seed heads.

⑨ Use white gouache or acrylic and a fine detail brush to extend the long white body feathers as needed. Add white sheen to some of the grasses. Use white/green gouache to add tips to the foreground grass blades and grass reflections to the water. Refer to the finished painting (opposite page).

"GREAT BLUE HERON, ESTUARY MARSH" Watercolor with gouache detailing, 8 x 10 inches (20 x 25cm)

"WISH YOU WERE HERE!" Watercolor miniatures detailed with pen and ink.

7

A Tropical Paradise

IF YOU TOOK THE SOFT BLUE-GREEN OF A ROBIN'S EGG, the gemstone colors of turquoise, chrysoprase, and aquamarine, and the shimmering teal-green eye of a peacock's tail feather, you would have the colors of tropical waves washing ashore over coral white sands. My Navy husband was stationed at Pearl Harbor for several years. The first time I saw the Hawaiian sea, I remember how surprisingly beautiful the colors were. I had to stick my toes in just to assure myself that the water was real. That's when I got my second surprise; the water was as warm as a baby's bath. I fell in love with the tropics then and there, and couldn't wait to unpack my paints and brushes. On the following page I will show you how to mix the colors of tropical waters, using tube paints which you may already have and a few that would be fun to invest in.

Sunshine is the key to making a beach scene bright, warm and inviting. It not only affects the color of the sea, but the landscape as well. To suggest the land portion of my tropical beach scenes, I choose colors from the warm side of the palette, those that contrast with the blue-greens of the sea. Even the deep green of the palm fronds have touches of Burnt Sienna and Cadmium Orange to brighten them. Adding sunbathers or flowers is another way to put patches of vivid color where needed for balance. Even the sand need not be bland: cream-colored sands look tantalizing when accented against violet-toned shadows. While I'm at it, I make sure that the shadows are dark. Nothing says sunshine like a strong contrast between highlights and shadows. If I need more dark shapes, I may add ironwood trees, shrubs or lava rock outcroppings.

On the facing page are a few watercolor scenes reminiscent of old-fashioned picture postcards—the kind of enticing greetings sent by friends, with the message "Wish you were here!" printed in big letters on the back. In this chapter I'm returning to the tropical beaches, complete with palm trees, coral sand, turquoise surf and sunbathers. You're invited to come along and paint with me, so grab your sun hat, your beach chair and your palette of bright hues and let's paint tropical!

Mixing the Colors of the Tropical Seas

Colors that work well for reefs and shallow areas.

*Base colors from a tube.

water added to lighten hue.

Complementary color added to produce shadow tone.

Base Color | Phthalo. Green | Tropical blue-greens | Red-orange added for shadow tone.

Cobalt Teal + scarlet Pyrrol =

Cobalt Teal + Phthalo = +

Turquoise + Scarlet Pyrrol =

Turquoise + = +

Manganese Blue Hue + Scarlet Pyrrol =

Manganese Blue Hue + = +

Phthalocyanine Blue + Scarlet Pyrrol =

Phthalo. Blue + = +

Cerulean Blue + Azo Orange =

Cerulean Blue + = +

Cerulean Blue Deep + Azo Orange =

Cerulean Blue Dp. + = +

Colors that work well for deep water areas beyond the reefs.

Anthraquinone Blue + Cadmium Orange =

Anthraquinone Blue + = +

Phthalocyanine Blue Red Shade. + Cadmium Orange =

Phthalo. Blue Red Shade + = +

✻ M. Graham & Co. watercolors were used to create this color mixing chart.

128

"THE NET CASTER" Watercolor detailed with gouache, 8 x 10 inches (20 x 25cm)

Creating a Soft-Edged Splash

Make your tropical ocean scenes more inviting by giving the surf a softer look. Here's how to do it.

① Use a Masquepen to mask out the white splash areas.

② Lay down a flat wash the color of the sea. Let it dry.

Make sure the pigment is rich enough to contrast the white of the splash.

③ Remove the masking. The edges of the splash will be crisp.

④ Dip a stiff, flat, bristle brush in water and work it gently back and forth along the edge of a section of white. As the paint loosens, blot it up. Don't scrub!

The goal is to soften the edges where the water and white splash come together, not to lift up bits of paper.

Overworked!

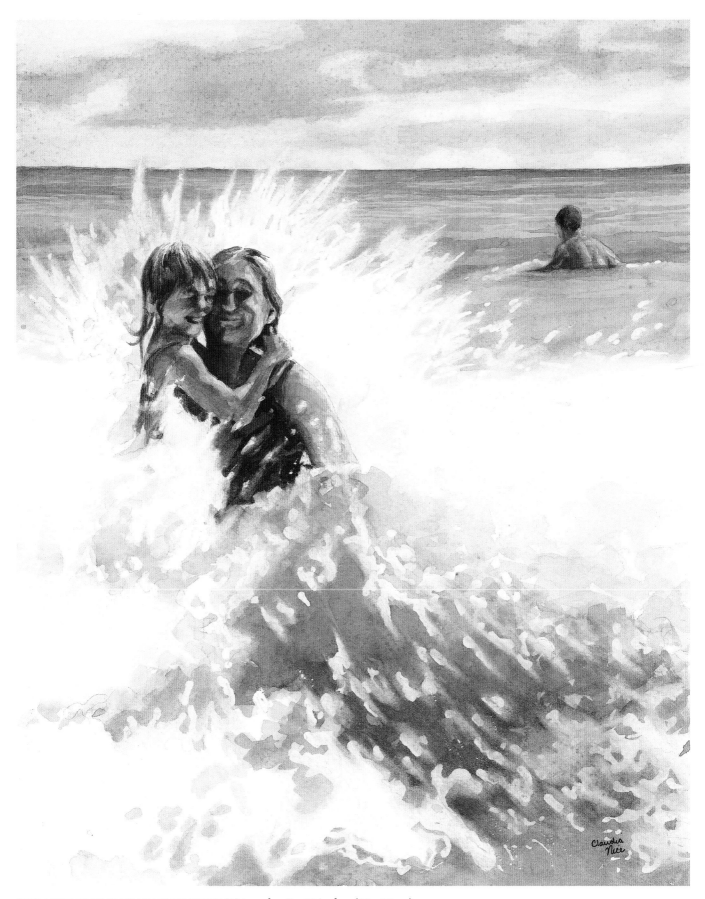

"SPLASHING IN HAWAIIAN WATERS" Watercolor, 8 x 10 inches (20 x 25cm)

Combining Several Favorite Photos Into One Tropical Scene

Here are the photos I worked from and a few notes on how I used them to create the watercolor painting shown on the opposite page.

Tropical beach plant to add color and unity to the foreground and mid-area of the beach.

A nice stand of ironwood trees to add curving lines in the background

These trees are backlit. They will need to be lit from the left to match the lighting in this photo.

This is my daughter Laura, age 6, in Hawaii. I like the pose, but I'm going to darken her hair and skin for a Polynesian look. A few sunbathers on the beach would add to the relaxed feel.

Add a circlet of flowers.

A quick thumbnail sketch helps me envision how my focal point will look

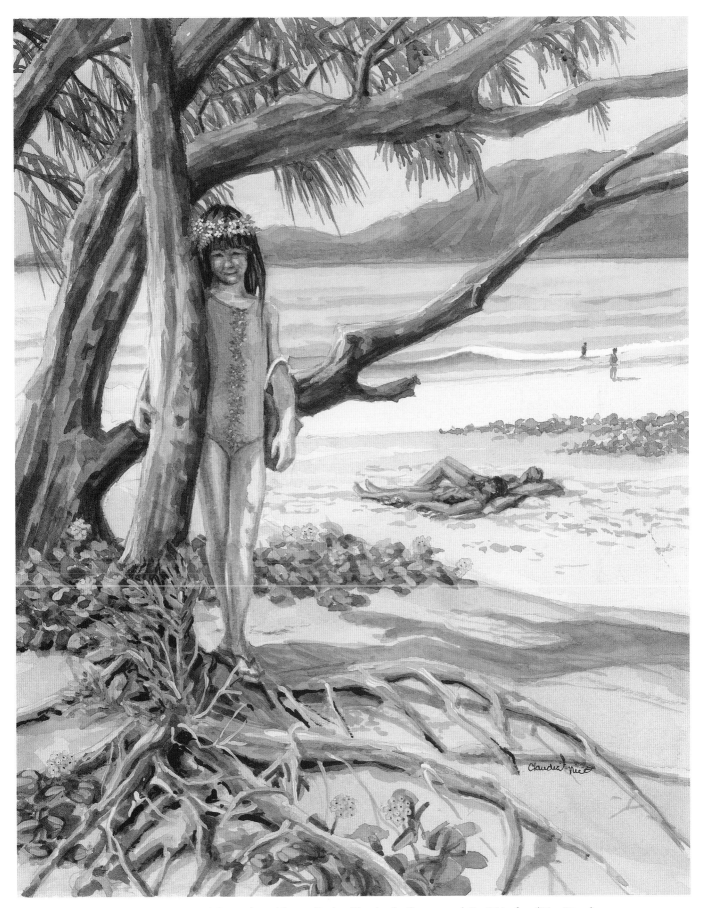

"UNDER THE IRONWOOD TREES" Watercolor with acrylic detailing in the foreground, 8 x 10 inches (20 x 25cm)

Coconut Palms

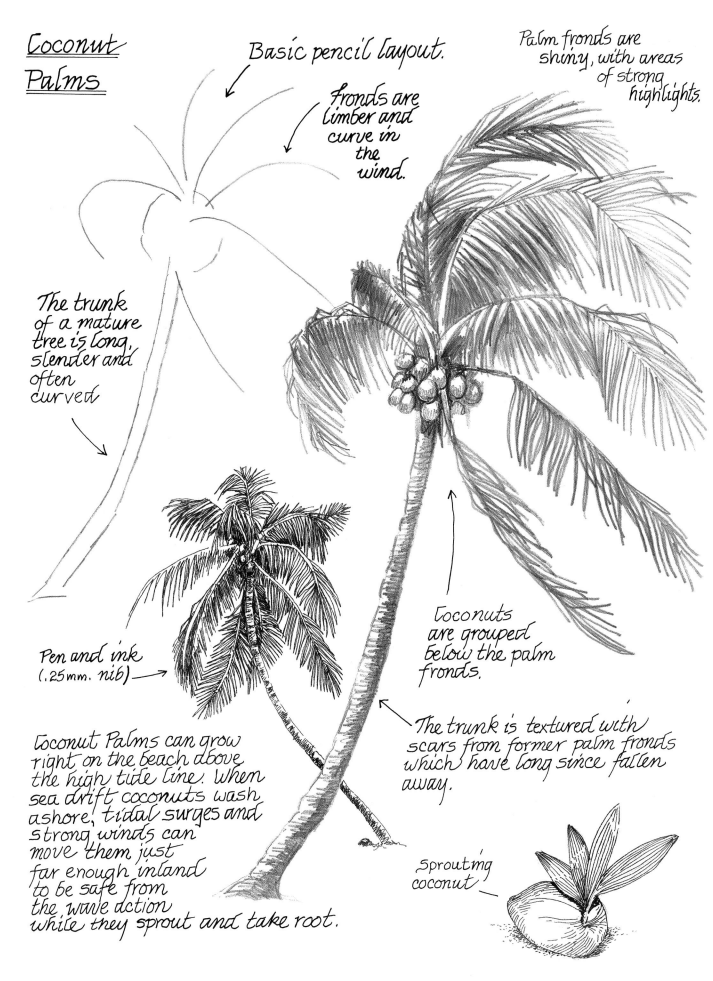

Basic pencil layout.

Fronds are limber and curve in the wind.

Palm fronds are shiny, with areas of strong highlights.

The trunk of a mature tree is long, slender and often curved

Pen and ink (.25mm. nib)

Coconut Palms can grow right on the beach above the high tide line. When sea drift coconuts wash ashore, tidal surges and strong winds can move them just far enough inland to be safe from the wave action while they sprout and take root.

Coconuts are grouped below the palm fronds.

The trunk is textured with scars from former palm fronds which have long since fallen away.

Sprouting coconut

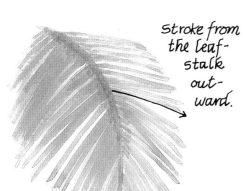
Stroke from the leaf-stalk out-ward.

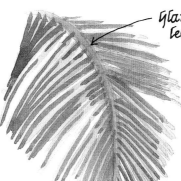
Glaze the leaf-stalk with pale orange.

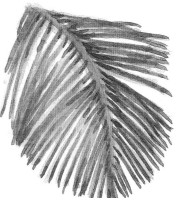

Paint a Palm Frond

① Use a liner brush and yellow-green to block in the shape.

② Darken the leaflets with either **Sap** Green or Hunter's Green. Allow **some of the** base color to show through.

③ For an older looking frond, paint the tips of the leaflets reddish brown.

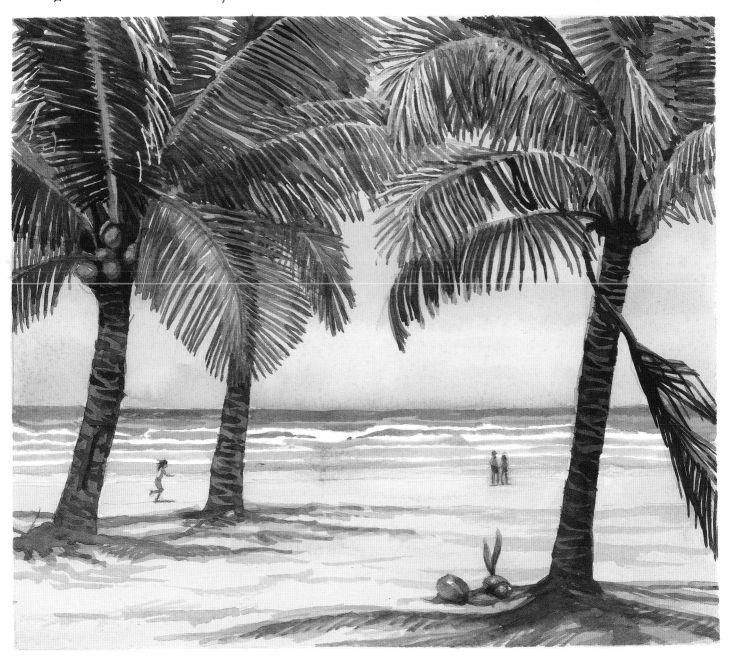

Painting Textured Lava Rocks

Lava boulders, peppered with holes and fissures, can add wonderful texture to a tropical beach scene. Here's how to paint them step by step.

1. Dampen the paper surface in the rock areas and lay down a Burnt Umber wash. I used a half-inch flat brush. Before the wash dries, tap it sparingly with a crumpled facial tissue to add light design areas. Let the paint dry.

①

②

3. Spatter the lava rocks with Sepia, Burnt Sienna and Burnt Umber. I accomplished this by flicking a loaded flat brush off my index finger.

③

Blot up stray splatter marks before they soak into the paper.

2. Dab a wash of Burnt Umber, mingled with a few strokes of Burnt Sienna, over the dry base wash. Use Sepia in the areas of shadow. This multi-colored wash should be very wet. Small, standing puddles are fine. Sprinkle beach or fine river sand into the wet wash, using care not to let the sand pile up thickly in one area. Allow the sand to remain until the paint is completely dry, then brush it away. A sand print will remain.

Cast shadow

Curved edge

④

Abrupt edge

4. In step number four, the lava rocks gain their contour by adding the shadows. Use a number four round brush and Sepia or Sepia mixed with Payne's Gray to lay down dark, distinct shadows. Leave the edges hard for abrupt bends in the rock or to indicate the edge of cast shadows. To show curved areas, use a clean, damp, round brush to blend and lighten the paint along the edges. Use lighter washes of Burnt Sienna mixed with Sepia to suggest slight indentations in the rock.

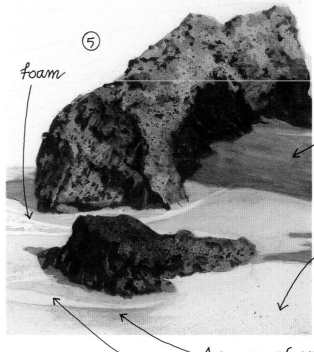

Distant rock outcropping

foam

⑤

Cast shadow

Drier sand with fine spatter.

An area of very wet sand.

Standing water.

5. Anchor the lava boulders into the scene by placing them in their surrounding terrain; in this case, wet sand.

I used a mix of yellow-orange and blue-violet to create the color of the sand. Use lots of water in the mix to bring it to a pale, off-white tint. Allow the color to be slightly more intense to suggest wet sand areas.

Add Dioxazine Purple to the mix to darken it for a "cast shadow" shade.

Foam ripples are left white or painted a very pale version of the sky color. (See the following page).

Overcoming Paper Flaws

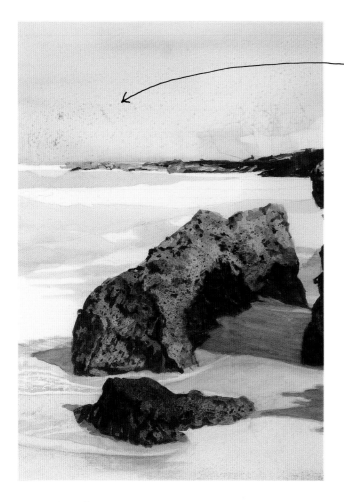

As I continued to develop the painting started on the previous pages, I ran into a problem.

I laid a flat wash of Manganese Blue Hue across the sky, using a half-inch flat brush, and out popped a series of dark speckles. A flaw in the finish of the paper had caused the pigments to gather unevenly. When the paper and paint react in this manner, neither blotting or repainting will fix the problem. As an artist who enjoys creative control, I did not find a polka dot sky acceptable, nor did I want to start the painting over.

Here is the solution I came up with.

1. I allowed the paint to dry completely.

2. I placed the sharp edge of a razor blade flush against the paper and scraped gently in the area of the dark specks, moving in a horizontal band across the page. Slowly, white paper began to appear where the specks had been. I had to scrape carefully, smoothing the paper as I went. The result was an area of white and pale Manganese Blue that looked misty, like distant clouds.

3. I brushed the area with clear water to help settle stray paper fibers. When the paper had dried, I laid down a few strokes of white gouache to accent the clouds.

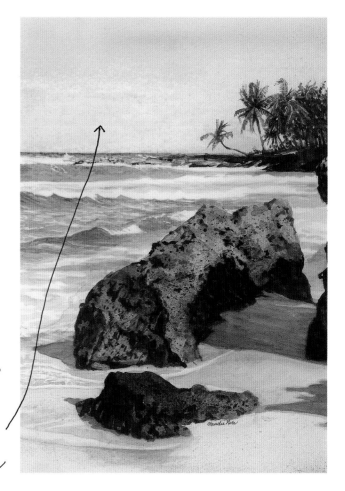

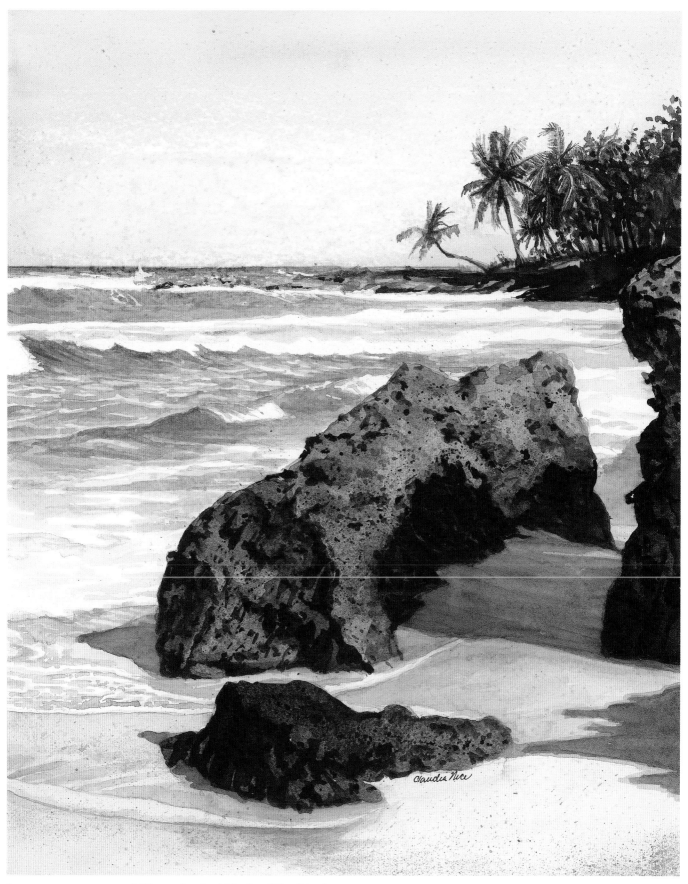

"LAVA OUTCROPPING" Watercolor, 8 x 10 inches (20 x 25cm)

Painting a Tropical Sunset (watercolor)

1. Sketch your favorite surf scene or use this one if you like. Draw in a round, penny-sized sun shape.

2. Use a small round brush and paint a ring of light Permanent Green Pale around the outer edge. While the green is still moist, widen the circle with a mix of Azo Yellow / Perm. Green Pale. Blend the edges.

Gamboge

Gamboge plus Quin. Rose

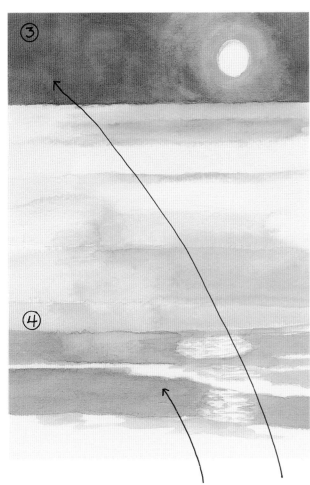

A	B	C	D

Gamboge with various amounts of Quinacridone Rose added.

Quinacridone Violet added to the mix.

3. Switch to a 1/4 inch flat brush and add a ring of Gamboge, blending the edges. Continue to work across the page in both horizontal directions using color mixtures A through C, and D on the left hand side.

4. Block in the sky reflections using all of the colors mentioned so far.

5. Block in the surf.

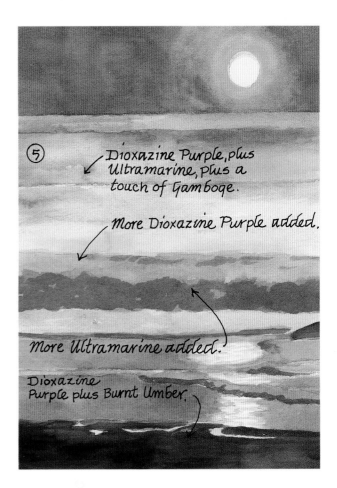

Dioxazine Purple, plus Ultramarine, plus a touch of Gamboge.

More Dioxazine Purple added.

More Ultramarine added.

Dioxazine Purple plus Burnt Umber.

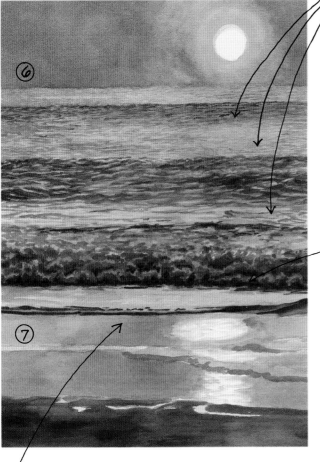

6. Using the techniques described on page 114 for creating the look of choppy water, begin to develop the texture of the ocean swells behind the breaking surf. I used a no. 3 and 4 round detail brush and slightly darker mixtures of paint. In the reflective areas, on the crests of the swells directly below the sun, I deepened the color using mixes B and C. When it had dried, I suggested choppy water by painting in ripples using mixture D.

7. The colors that have already been blocked into the breaking surf area will form the lighter foamy patches. Darker shadow areas need to be added beneath each patch of foam to give it dimension. The dark shadow shapes should be loose and spontaneous.

Darken the front edge of the shallow, incoming wave.

8. Stroke thin streaks of Phthalo Blue wash horizontally across the foreground pool of incoming water to suggest scattered bits of foam. Allow an equal amount of orange to shine through vividly.

Darken the lower edges of the foreground wave.

9. Work horizontal bits of the dark sand color into the orange wet sand area to look small rocks and sea weed. Add the same color to the shallow wave to create really dark shadows.

10. Use white gouache and white gouache tinted with yellow or orange to add highlights to the reflections. See next page.

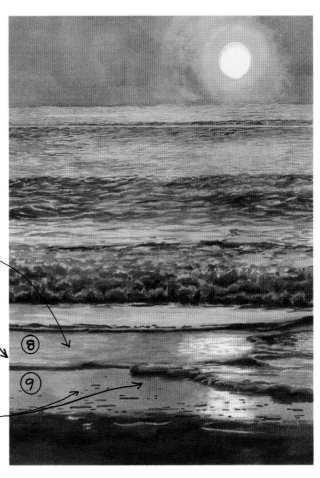

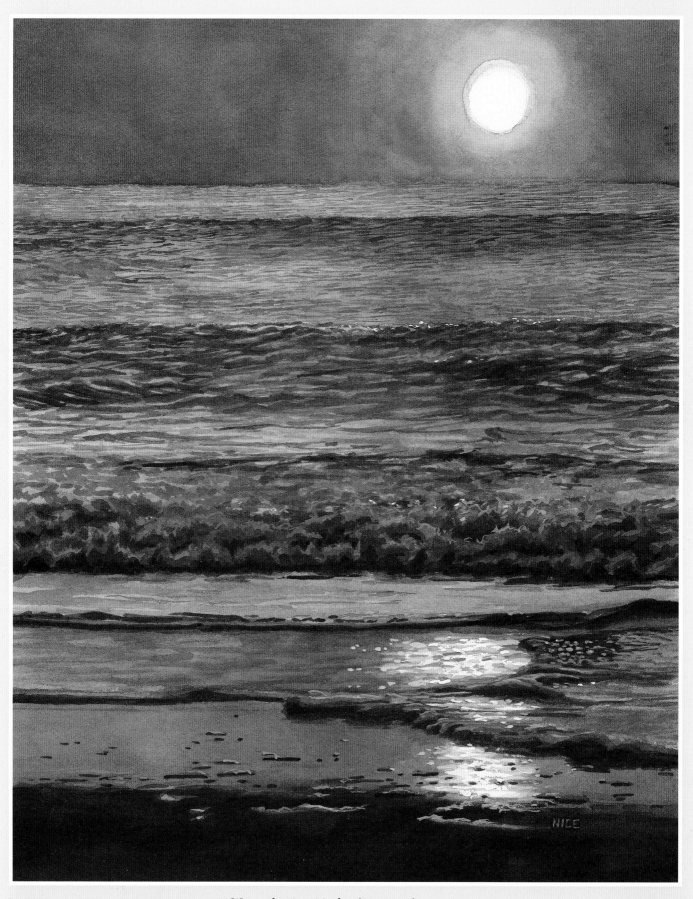

"SUNSET IN QUINACRIDONE ORANGE" Watercolor, 8 x 10 inches (20 x 25cm)

Index

THE BEST IN ART INSTRUCTION IS FROM

North Light Books!

CREATING TEXTURED LANDSCAPES WITH PEN, INK AND WATERCOLOR

Capture nature's beauty as you never have before. Beloved artist and teacher Claudia Nice leads you on an inspired journey through the great outdoors. With pen and brush in hand, Claudia shares with you her best techniques for creating landscapes that come alive with richness, depth and textural detail. More than 60 step-by-step demos, reference photos and field sketches show you how to draw and paint the realistic natural textures that make a difference between run-of-the-mill landscapes, and paintings that spring to life!

ISBN-13: 978-1-58180-927-5; ISBN-10: 1-58180-927-1; hardcover, 144 pages, #Z0568

ROBERT WARREN'S GUIDE TO PAINTING WATER SCENES

Painting water effects can be a challenge for any artist! *Robert Warren's Guide to Painting Water Scenes* answers that challenge and shows how to create water in all its forms and in all seasons. Renowned artist and nationally televised teacher Robert Warren shares his own special secrets for capturing ocean waves, waterfalls, quiet reflective lakes, woodland streams, whitewater cascades and more in 12 easy-to-follow painting demonstrations that begin with an acrylic underpainting and finish with oils. If you are taking your first "plunge" or if you're a seasoned pro, painting water will no longer be a mystery!

ISBN-13: 978-1-58180-851-3; ISBN-10: 1-58180-851-8; paperback, 128 pages, #Z0054

ACHIEVING DEPTH & DISTANCE

Achieving Depth & Distance helps you paint realistic landscapes by showing you the correct colors, values and textures to express near, middle and great distance. Ten step-by-step oil painting demonstrations on canvas teach you how to paint a wide variety of subjects, scenery and seasons with a convincing depth of field. Colorful diagrams, reference photos and eye-catching side-by-side comparisons make it easy and fun to learn these important techniques.

ISBN-13: 978-1-60061-024-0; ISBN-10: 1-60061-024-2; paperback, 144 pages, #Z1308

PAINTING PEACEFUL COUNTRY LANDSCAPES

Experience the joy and satisfaction of painting your own charming country scenes with this complete step-by-step guide. Ten start-to-finish painting demonstrations teach you to paint a range of realistic pastoral scenes, from misty waterfalls and mountain pines to fragrant fields and rolling farmland. You'll find both oil and acrylic painting demos with a handy color conversion chart that lets you work in the medium you're most comfortable with.

ISBN-13: 978-1-58180-910-7; ISBN-10: 1-58180-910-7; paperback, 144 pages, #Z0608

These books and other fine North Light titles are available at your local arts and crafts retailer, bookstore or from online suppliers. Visit our Web site at www.artistsnetwork.com.